IMAGES
*of America*

# HUBBARDSTON

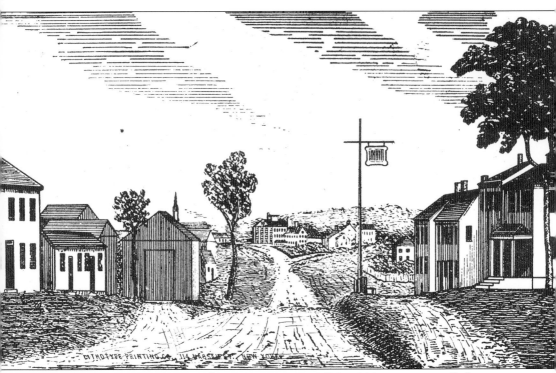

Hubbardston was made into a district on June 13, 1767. In 1786, it automatically became a town by a general act of the legislature, which stated that all places incorporated as districts prior to 1777 were declared to be towns. Here is a sketch of Main Street looking north from the common, as it may have looked in 1839. This image was printed in *Hubbardston Illustrated 1899.*

*On the cover:* Please see page 41. (Courtesy of Hubbardston Historical Society.)

# IMAGES of America
# HUBBARDSTON

Gary W. Kangas

Copyright © 2009 by Gary W. Kangas
ISBN 978-0-7385-6515-6

Published by Arcadia Publishing
Charleston SC, Chicago IL, Portsmouth NH, San Francisco CA

Printed in the United States of America

Library of Congress Control Number: 2008942866

For all general information contact Arcadia Publishing at:
Telephone 843-853-2070
Fax 843-853-0044
E-mail sales@arcadiapublishing.com
For customer service and orders:
Toll-Free 1-888-313-2665

Visit us on the Internet at www.arcadiapublishing.com

*This book is dedicated to those who have helped preserve Hubbardston's history and heritage. Anyone who has photographs or documents to donate to the Hubbardston Historical Society's collections can drop them off at the Hubbardston Public Library. If there are items one does not wish to part with permanently, they can be scanned and returned.*

# CONTENTS

| | | |
|---|---|---|
| Acknowledgments | | 6 |
| Introduction | | 7 |
| 1. | Main Street | 9 |
| 2. | The Country Roads | 43 |
| 3. | Healdville | 63 |
| 4. | Pitcherville | 71 |
| 5. | Williamsville | 83 |
| 6. | Things Remembered | 87 |
| 7. | Center School | 103 |
| 8. | Wain-Roy Company | 113 |

# ACKNOWLEDGMENTS

I wish to thank my Lord and Savior Jesus Christ for the little talent I possess, and my wife, Donna, for her perseverance with me on this project. Special thanks go to historian Jane McCauley and especially Bonnie Cunningham for assistance in editing and writing. Thanks to the Hubbardston Historical Society (HHS) for its support in granting me access to all the photographs, documents, and maps in its museum archives and to the generous people who donated those items. I am indebted to the Hubbardston Historical Commission for its support in getting information, photographs, and documents and to Velma Rivers for access to her extensive collection of historical photographs. Thanks go also to the following for access to their private collections of photographs, maps and documents: Alden Adams, Brian Handy, Charles Clark, Larry Kangas, Louis and Anne Richard, and Nancy Kangas. A special thanks goes to Erin M. Rocha, my editor at Arcadia Publishing, for guiding me through the writing process. The information in this book came from many sources, including the Rev. John M. Stowe's *History of Hubbardston* of 1881; Leo J. Sullivan's *History of the Town of Hubbardston 1881–1976*, the *Hubbardston Pictorial* of 1899, and the *Hubbardston Pictorial* of 1982; the research done by Margaret Hepler on the historical homes in Hubbardston; the Hubbardston Historical Society's museum archives and *Hubbardston Illustrated 1899*; and numerous interviews with many of Hubbardston's residents.

# INTRODUCTION

Located in the rolling hills of central Massachusetts is a diamond-shaped district of land approximately 35 square miles in area that was a part of Rutland, purchased from the Naquag Indians in 1686. The northeast quarter of this land later became known as the town of Hubbardston. In 1737, this land was divided into 68 house lots of 100 acres each and 33 great farms of 500 acres each. Various lots were set aside for schools, churches, roads, and a common. This land was offered to pioneers who would settle here. Eleazer Brown and his wife came from Rutland in 1737 and were given a 60-acre parcel, providing that he "keep a house thereon for the entertainment of travelers for a span of seven years." Brown lived there until his death in 1747. His wife remained as the only settler until 1749 when Israel Green and his family settled here. Green's daughter Molly was the first child born in Hubbardston. A petition for the district of Hubbardston was read to the council and representatives, and the governor of the colony signed the petition on June 13, 1767, thereby giving formal recognition to the district of Hubbardston. It became a town when the state legislature declared in March 1786 that all places incorporated into districts prior to 1777 were officially towns. By that time, 30 families totaling 150 people had settled here. Hubbardston began as a rural farming community, but since it had so many natural streams, dams with millponds were created to use the waterpower to run numerous mill sites. Because of the mills, small villages, parts of the larger town, sprang up along these watercourses. There were many sawmills, gristmills, and carding mills. In Healdville, the Wachusett Nail Company used the water from Mason Brook to run the many machines contained in the mill. The water running this mill continued downstream and ran several other mills, including the Coffin mill that made woodturnings, toys, and novelties. The village of Pitcherville had several farms and mill sites. The Greenwood Chair Factory, Bent Brothers, and the Pierce Chair Factory began here before they moved to South Gardner. Williamsville has a millpond where the first electricity was generated. Since Hubbardston was on a central travel route going north and south, there were several inns and hotels in town. There were many changes with the coming of the railroad in 1871 and many more with the great influx of Finnish immigrants who settled here from the end of the 19th century through the first two decades of the 20th century.

These hardworking farmers strengthened the town's agricultural base. Some of the noted residents of Hubbardston were Adam Wheeler, who was second in command at Shay's Rebellion; Jonas Gilman Clark, founder of Clark University and donor of the town's library; and in the 20th century, Waino Holopainen and Roy Handy, who invented the first hydraulic backhoe.

## One
# MAIN STREET

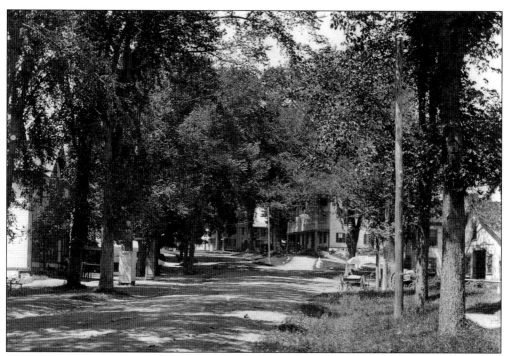

Main Street, now Route 68, was a country road as far back as 1767. This was a main travel route, running north and south between Keene, New Hampshire; Worcester; and Providence, Rhode Island. Travel was slow, using a horse and buggy or a stagecoach, and the roads were very dusty. Hubbardston offered several inns, hotels, and bed-and-breakfasts, where one could rest and freshen up. (Courtesy of HHS.)

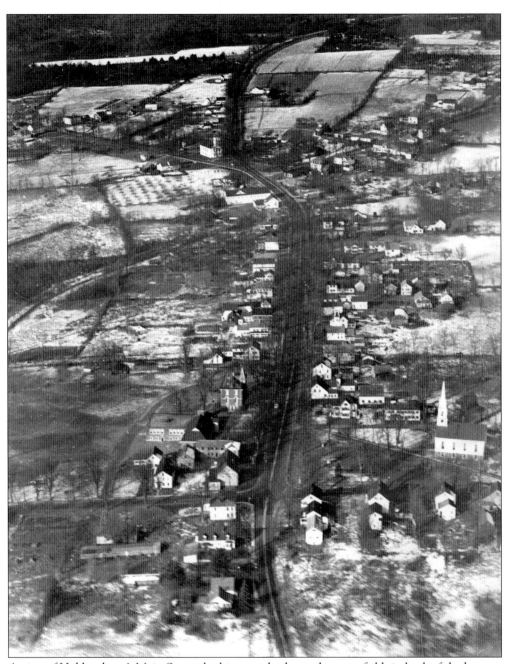

A view of Hubbardston's Main Street, looking north, shows the open fields in back of the houses. Because everyone heated their homes with firewood, much of the land was clear cut, creating a lot of open pasture for grazing farm animals and harvesting hay for the winter months. There were six roads leaving the Main Street area of town, including New Templeton Road, which later became Route 68 north when it branched off and joined the north end of High Street; High Street; Williamsville Road; Worcester Road south; Brigham Street; and Elm Street/Barre Road. (Courtesy of HHS.)

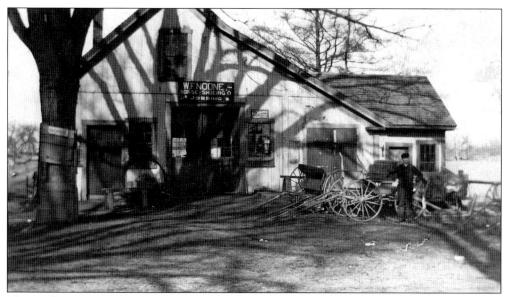

The William F. Noone blacksmith shop was located on Main Street to the right of the Hubbardston Inn on the site of the former Asnacomet Federal Credit Union. Noone was born on September 28, 1879. The blacksmith shop, which was destroyed in the great fire of 1929, can also be glimpsed on the right in the photograph on page 9. (Courtesy of HHS.)

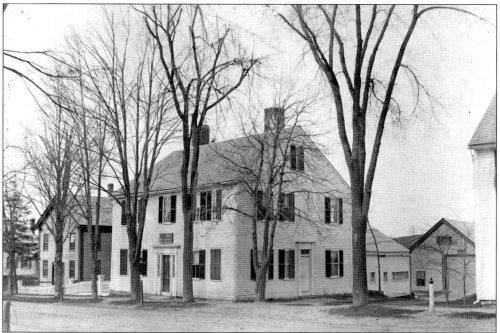

Hubbardston had many little shops and businesses along its Main Street. This building at 8 Main Street was the S. C. Young Real Estate Agency. The family market was next to the present-day post office. William Merrifield Clark began his business in January 1885, opening a job printing office on Main Street. In 1887, he built a new store on Main Street at the former site of the Mechanics Hall, which had burned in 1877. The store is shown on the left side of the photograph on page 9. (Courtesy of HHS.)

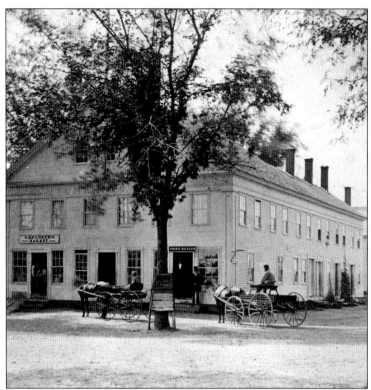

The Mechanics Hall was built on Main Street by Ethan A. Greenwood sometime before 1843, where the present-day Mr. Mike's convenience store is now located. Capt. Lyman Woodward was Hubbardston's postmaster then and ran a drugstore in the building beginning in 1870. The post office was moved into the Jonas Gilman Clark library building in October 1875. A fire destroyed Mechanics Hall in February 1877. (Courtesy of Alden Adams.)

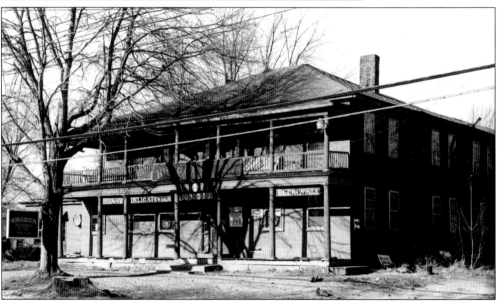

The Hubbardston General Store has had a varied history. It was built around 1790 and owned by William B. Goodnow. It was also a post office with Goodnow as postmaster. Other owners over the years included J. W. Holbrook; William Warren; Lois E. Warren; Sarah Ward Gould; Lyyli and Hugo Puntanen; Bruce Gunnard, who had an old-time country store there until the mid-1980s; Paul Rouleau; and Claudia Provencal, who ran a beauty shop and a gift shop in the building since. (Courtesy of HHS.)

On the corner of Main and Elm Streets is the Wheeler Brothers General Store. It was originally owned by Abijah S. Clark in 1845. Later owners included William Bennett, William M. Morse, and Walter E. Howe; in 1875, William and Edwin Wheeler took over the business. It passed through several generations of the Wheeler family up until 1968, when Silas Wheeler retired. He then passed away on December 23, 1970. (Courtesy of HHS.)

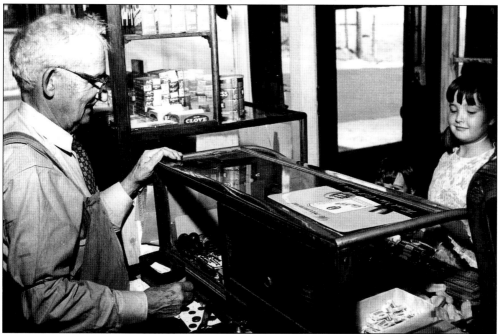

The Wheeler Brothers General Store had a 1937 Chevrolet delivery truck that was used until the store closed in 1968. Not everyone in town had a telephone, and no one had more than one automobile, so as a service, the Wheelers went around town on Wednesdays taking grocery orders. On November 18, 2001, the store and all its contents were auctioned off. Here from left to right are Gwendolyn and Patrice McCauley buying penny candy. (Courtesy of Jane McCauley.)

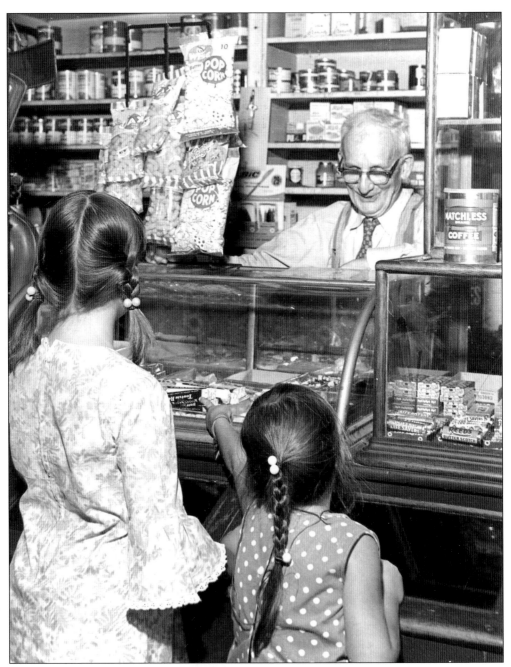

The Wheeler Brothers General Store was a favorite place for the children of Center School to get their penny candy. Silas Wheeler liked to teach the children their arithmetic by asking them how much change they should get back. Many times he would get an unusual old item from the back room and have children and adults try and guess what it was. Many great stories and political issues were discussed around Wheeler's potbellied stove. At the time of the auction, it was like opening a time capsule. The high bidder on the 1937 Chevrolet paid $18,000 and drove it home. (Courtesy of Jane McCauley.)

The Wheeler brothers had everything in their store that a household needed. They sold clothing, hardware, canned goods, dry goods, and many items that were bought in bulk, such as flour, molasses, cheese, and eggs. The store also sold fresh meat, since it had its own icehouse in the back. Many farm customers traded eggs and fresh produce from their gardens to help pay for their orders. (Courtesy of HHS.)

The Wheeler house on upper Main Street was built in 1840 and is believed to have been built by Horace Morse. His son William Morse took it over in 1869. William H. Wheeler bought the house in 1885, and the first telephone switchboard, a magneto-type, was moved there from its original site in Wheeler's store where it had been installed in June 1904. The Wheeler sisters Katherine and Bessie Wheeler, along with a third woman, served as the first telephone operators. (Courtesy of HHS.)

In Jonas Gilman Clark's later years, he decided he wanted to leave something behind that was significant. He wanted to build a college in Hubbardston, but the town fathers did not want "a group of rowdy college kids in town," so they turned him down. He later built Clark College in Worcester, which later became Clark University. However, he left Hubbardston a beautiful free public library building. He first donated the land where the building was to be located and later paid for its construction. Above the entrance is the inscription, "Jonas G. Clark 1874." (Courtesy of HHS.)

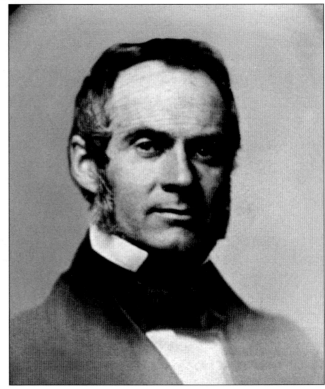

Clark was a successful businessman during the period of the Civil War. He was born in Hubbardston on February 1, 1815. He had very little formal education, but from very early on, he was successful at business. (Courtesy of HHS.)

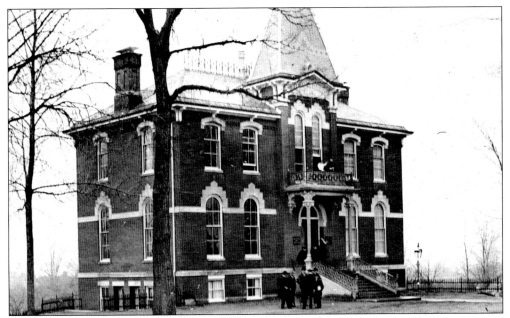

Clark went to great lengths to create a cleared lot to place "a well-positioned library building on Main Street." There were several buildings moved. The barn across the street next to the former Homans house was moved there from this lot. The above photograph looks like the new library has just been completed, and a group of men are inspecting the work. Note the ladies on the balcony above the entrance. (Courtesy of Alden Adams.)

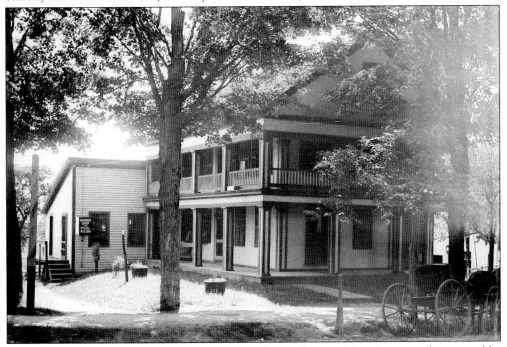

Clark went into carriage manufacturing, operated a tin shop on Main Street, and prospered by selling supplies to the California gold miners in the 1850s. On the front of the house he built on Main Street, there is an inscription, "Jonas G. Clark 1847." (Courtesy of HHS.)

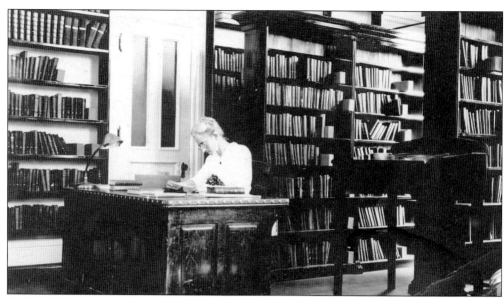

Lucy Harriet Clough was born on August 30, 1873. She began her career as Hubbardston's librarian in February 1897, earning a yearly salary of $50 and working four hours a week. She served for 62 years, retiring in 1959. Clough was known as "aunt Lucy" to library patrons, young and old. She passed away on March 12, 1961. The library trustees named the children's room in the library the Lucy Clough Room in her honor. (Courtesy of HHS.)

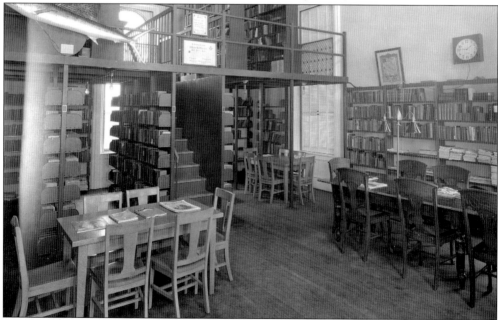

The town library was moved from Mechanics Hall to the new library building in September 1875. The first floor was half library, with a 27-foot ceiling, and half post office, with a 15-foot ceiling. The room above where the post office used to be is the present historical society museum. At one time, the police station and all the town offices were located in the basement level of the building. The Asnacomet Credit Union's first office was located there when it began. (Courtesy of HHS.)

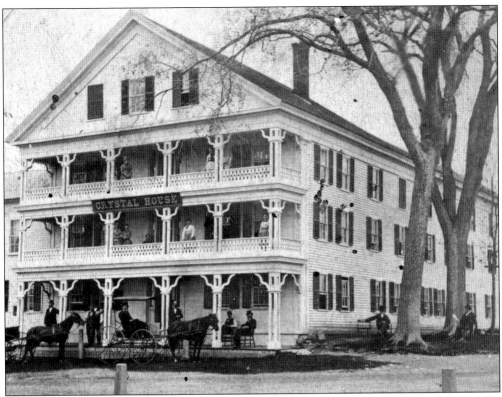

The Crystal House was also known as the Central Hotel and was located on Main Street across from the library. William H. Morse, with Capt. S. B. Beaman as proprietor, owned it in 1870. A fire destroyed it in 1880. Elwin Wheeler then purchased the land and built a Victorian home there in 1892. Until recently, it belonged to the Homans family. The barn was moved from Leonard Field to this location. (Courtesy of Alden Adams.)

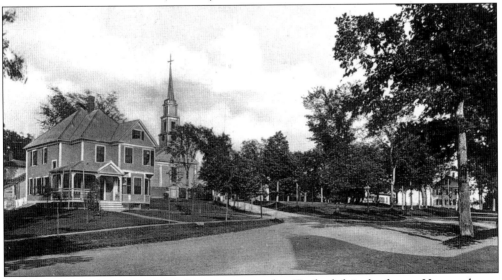

This view shows the common much as it is seen today. To the left is the former Homans house that Wheeler built on the site where the Crystal House had been located. (Courtesy of HHS.)

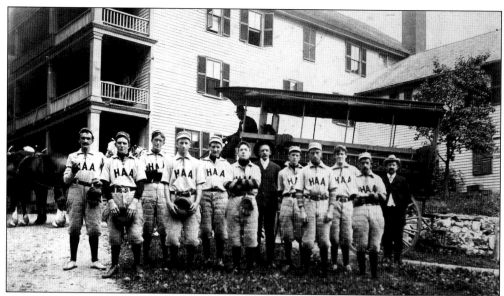

The Hubbardston Athletic Association team is shown in front of the Hubbardston Hotel on upper Main Street in 1898. From left to right are Charles Smith, Dwight Pierce, William Green, Harold Woodward, unidentified, Frederick McWilliams, Simpson Heald, unidentified, James McWilliams, William Coffin, unidentified, and C. F. Randall, the driver of the large horse-drawn vehicle in back. He was the owner of the hotel. (Courtesy of Hubbardston Historical Commission.)

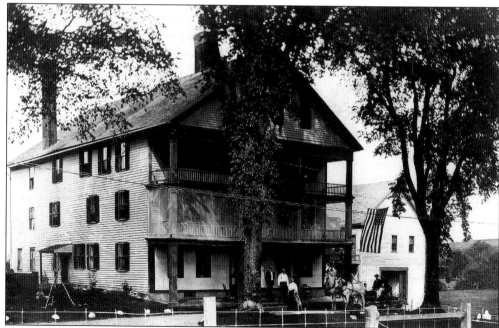

The Hubbardston Inn, just like the Crystal House on the other end of Main Street, faced a decline in business with the coming of the railroad in 1871. With better roads and the advent of the automobile later on, there was even less need for travelers to stay over, where they could arrive at their destination in one day. In the end, the rooms were rented out as apartments. (Courtesy of HHS.)

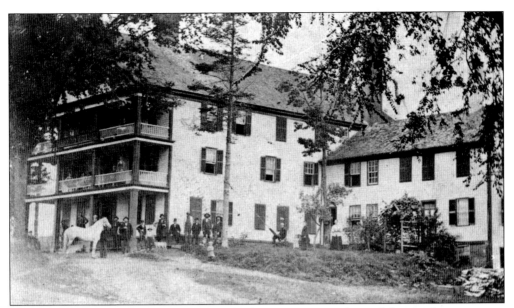

The Hubbardston Inn was located where the fire station is now located. It served as a rest stop for travelers going between Keene, New Hampshire; Worcester; and Providence, Rhode Island. It was originally the Old Clark Tavern. It was rebuilt by Ethan A. Greenwood and called the Star Hotel. In 1889, E. G. Stanbridge took it over and renamed it the Falmouth House. The hotel was destroyed in the great fire of 1929. (Courtesy of HHS.)

Maurice Pender's barbershop was originally built to be a post office in 1864. It was later used as an ice-cream parlor. Gustaf Norberg, who owned the building, tore it down in the late 1940s. Norberg lived in the house next door. (Courtesy of HHS.)

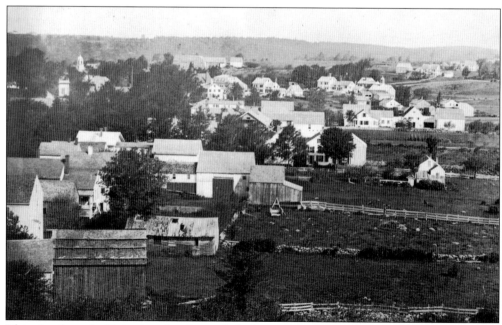

This view from the Unitarian church steeple looks north at the back side of Main Street in 1931. In the top left, the steeple of the Congregational church can be seen. Joseph Homans, who also served as postmaster, owned the barn on the bottom left. Notice the openness of land, where most of the land was clear-cut. (Courtesy of HHS.)

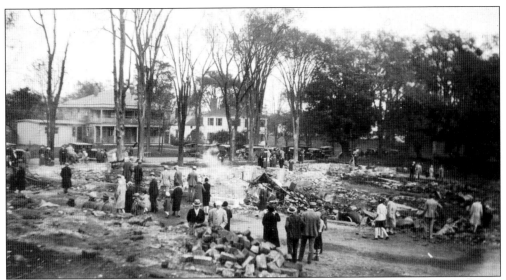

On the night of October 13, 1929, there was a dance sponsored by the Finnish Cooperative Exchange upstairs in Bennett's Hall. A cigarette was tossed into the outhouse in the rear of the building. It was a very windy night, and when the fire started, sparks flew all the way to the other end of Main Street. The sky lit up that night and could be seen for miles. (Courtesy of HHS.)

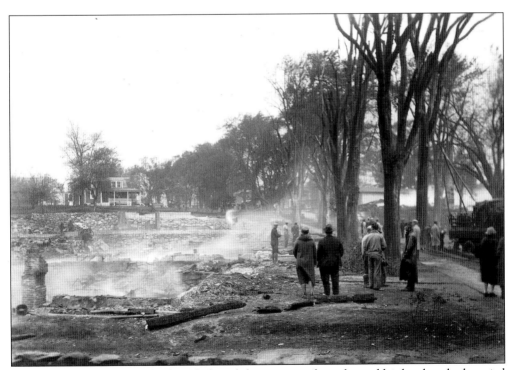

Remembering the event, Charles Clark said that as young boys, he and his brothers had carried buckets of water onto the roof of their house, which was on the other end of Main Street, extinguishing embers as they landed. On top of this disaster, about two weeks later, the stock market crashed. (Courtesy of HHS.)

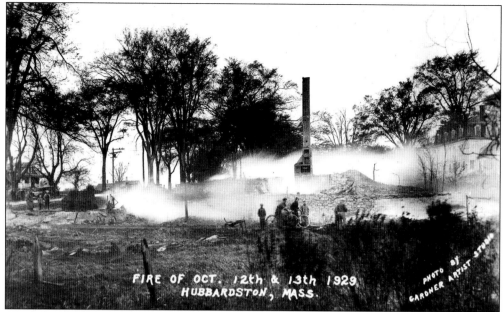

All the area towns came to help with the fire. Even the Worcester Fire Department responded. The nearest water supply was almost a mile away. Men fighting the fire had to run a hose from Brigham Pond to the center of town and soon realized that they had brought together two ends that had female connectors. With a truck, they had to drag one end of the hose back down to Brigham Pond and the other end back, costing them crucial time in fighting the fire. This is all that remains of the Hubbardston Inn. (Courtesy of HHS.)

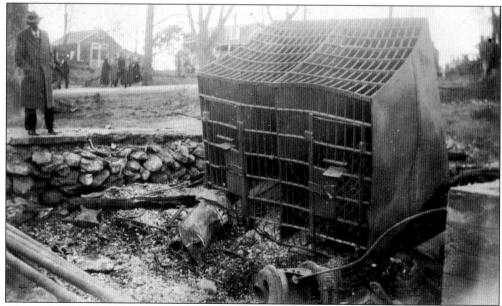

Above, the jail cell is all that remains at the lockup. A prisoner was released from the cell when the fire broke out. Other buildings that were destroyed in the fire were the homes of Alton W. Clark, Edward Pierce, George W. Maynard, and William Merrifield Clark, and the garage of Frank E. Marean. The fire became known as the great fire of 1929. (Courtesy of HHS.)

In 1772, the Town of Hubbardston voted to build a meetinghouse. The frame was raised in June 1773. The windows were glazed in 1774. It was known as the First Parish Unitarian Church. Interestingly, the Unitarian church holds title to the building, but the church bell and clock in the steeple belong to the Town of Hubbardston. In the background is the old buggy shed, and back then, there were shutters on the windows. (Courtesy of HHS.)

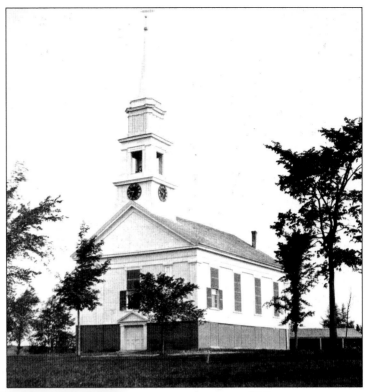

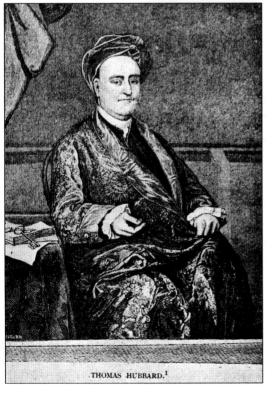

The church windows were glazed at the town's expense, since Thomas Hubbard, the state legislator for whom the town had been named, died before he could make good on his promise to provide glass for the windows. This is an etching of Hubbard. (Courtesy of HHS.)

Behind the First Parish Unitarian Church is the old burial ground, the oldest cemetery in Hubbardston. About 100 years ago, there were brambles and brush growing around the gravestones; they did not mow the grass in cemeteries back then. Someone had the idea to move all the stones and burn all the brush and brambles. When they went to put the gravestones back, they forgot where each one went. Just like the Evangelical Congregational Church on the other end of Main Street, this church was also raised up, and a fellowship hall was built underneath it. (Author's collection.)

The steeple of the First Parish Unitarian Church was blown off during the great hurricane of 1938. The Morgan family from the Morgan farm made a generous donation, and citizens and friends of the town rallied to raise money to replace the beautiful steeple, which was lighted in 1966. (Courtesy of Alden Adams.)

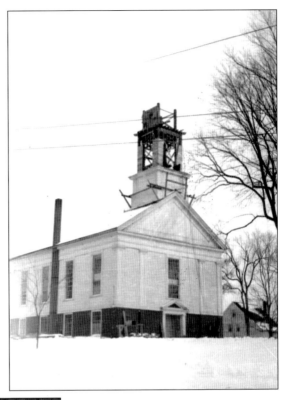

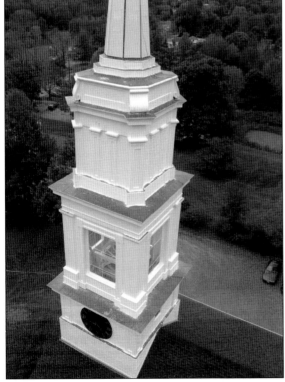

The bell suffered minor damage, but the entire steeple had to be replaced. The fancy millwork was redone just like it was originally. The Paul Revere Company made many New England church bells. An apprentice of Revere made this one. This photograph shows the steeple from a crane over the common in 2008 when the steeple got a new facelift. (Author's collection.)

The Evangelical Congregational Church was erected in 1827 at the other end of Main Street after it split from the First Parish Unitarian Church on the common. This church originally faced Petersham Road, now Williamsville Road. (Courtesy of HHS.)

In 1886, the Evangelical Congregational Church was raised up, and a fellowship hall was built underneath it. The church was turned about 90 degrees and now faces Main Street. (Courtesy of HHS.)

Rev. Joseph Whitman founded the Methodist church in 1839. The services were held in a hotel prior to construction of the building, which was dedicated on September 25, 1840. The church had over 100 members and was quite prosperous. It was located about halfway up Main Street on the west side. (Courtesy of HHS.)

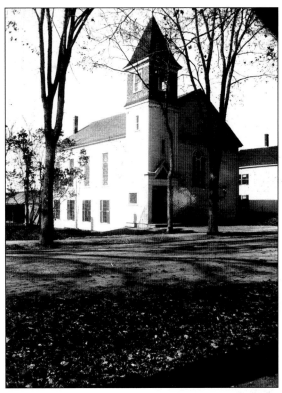

The last sermon at the Methodist church was delivered on June 7, 1942. When the building was sold, pieces of the stained-glass memorial windows were given to descendants of the people who donated them. (Courtesy of HHS.)

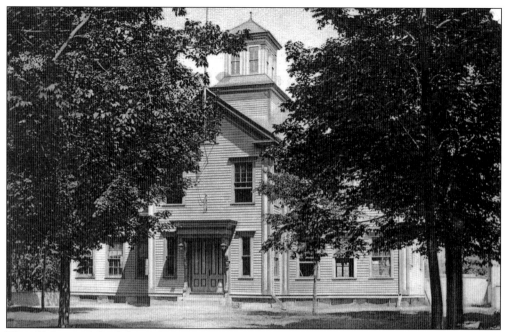

The old Center School, located on the east side of Main Street, was constructed in 1872 at a cost of $12,000. It had four spacious rooms on two floors and was heated by potbellied stoves. Each teacher's desk was on a raised platform in the front. There were two grades to a room: first and second together, then third and fourth, fifth and sixth, and seventh and eighth. (Courtesy of HHS.)

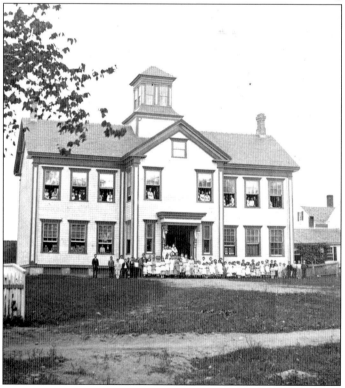

In the winter, students seated near the potbellied stove were warm, but those seated at a distance were cold. To use the bathroom, they went to the outhouse. The boys had to use a privy. In the winter, it was bitterly cold. With no lunchroom, the children brought bag lunches and ate at their desks. Children who lived nearby walked home for lunch. (Courtesy of HHS.)

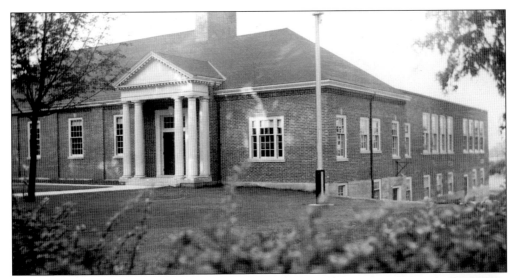

The old Center School was used for the last time in the 1938–1939 school year; a new building was in the process of construction on the opposite side of Main Street next to the library. It was dedicated on September 23, 1939. There were still two grades to a room, but there were flush toilets, central heat, a gymnasium/auditorium, and later a lunchroom that had benches for each of the eight grades; it also served hot lunches. Note that this photograph was taken before the 1954 addition was built. (Courtesy of HHS.)

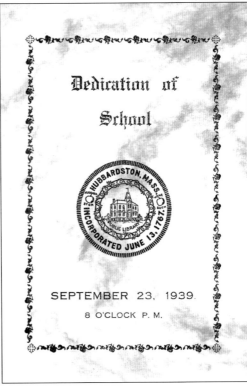

In January 1927, 10 Finnish farmers met at the farm of Wester Kuusisto to discuss forming a Farmers Cooperative and Trading Association for all the farmers in Hubbardston. At the February 7 meeting, the plan quickly took shape. Within a year, the co-op was incorporated, and Otto Kangas, Wilho Salminen, Frank Mackie, Victor Olly, Thomas Alanko, Victor Laiho, and Edward Niemi signed the charter. (Courtesy of HHS.)

With the sale of 33 shares of stock and $200, the farmers' co-op was on its way. This photograph shows the store on the left. The building on the right had grain and hardware downstairs and a fellowship hall upstairs where they held meetings and dances and showed movies. (Courtesy of HHS.)

The Finnish Americans were dedicated to forming cooperatives. Some of the cooperative's board of directors and employees were John Holopainen, Frank Mackie, Rev. Alexander Kukko, Hilda Nurmi, Lydia Rasinen, Julia Heino, John Hakkinen, Arne Rasinen, Emil Heino, Eino Olly, Bennie Autula, Otto Hakkila, Oscar Maki, Helen Maki, John Porko, Sulo Salminen, Eino Kari, Otto Sutela, Victor Olly, and Waino Wakkinen. (Courtesy of HHS.)

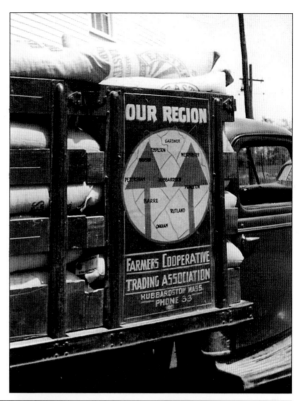

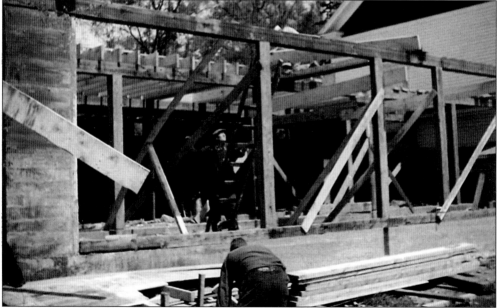

The Finnish farmers' co-op building on Main Street next to the present-day Mr. Mike's store was partly constructed by using timbers from the torn-down boot factory on Elm Street. The finished building had a hardwood floor for dances and basketball games and a stage area for meetings and entertainment. For many years, it was the hub of social life for those in Hubbardston. (Courtesy of Charles Clark.)

The quiet life of a small town is caught in this photograph from around 1900. It shows one of the finer homes at 11 Main Street. This one was originally owned by John Quincy Adams Morse. Like many of the old barns in Hubbardston, the one on this property was replaced with a newer structure, which in recent years has been an antique shop. Pictured from left to right are Adeline B. Morse, Charlotte Henshaw, and Harriet B. Warren. (Courtesy of HHS.)

This was a divided home because of a family dispute prior to 1870. The rear of this home at 31 Main Street was cut off and moved to Barre Road. It was owned by Herman Rivinoja in 1973. (Courtesy of HHS.)

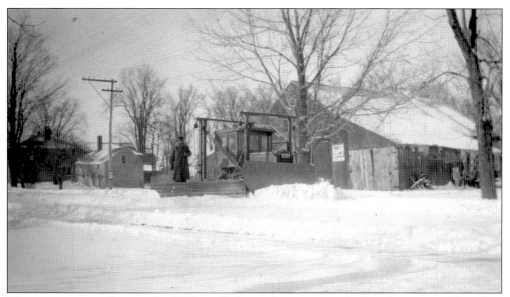

This picture was taken in the 1930s and shows the tractor and plow that was used to clear the streets of snow. The blades were worked by a pulley system, and it took two men to run the machine. In the background is the Clark General Store on the corner of High Street and the large barn that belonged to the Ylonen family that burned in the 1950s when it was full of hay. (Courtesy of HHS.)

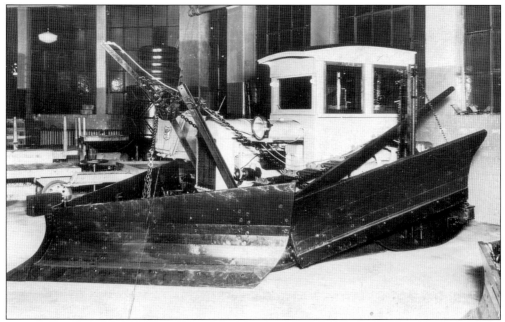

This is the old Holt snowplow that was used in the 1930s. It was said that during Prohibition, Edwin Bemis, who made hard cider, had his driveway plowed out for nothing because the operator of this plow cleared his horseshoe driveway for a few samples of hard cider. (Courtesy of HHS.)

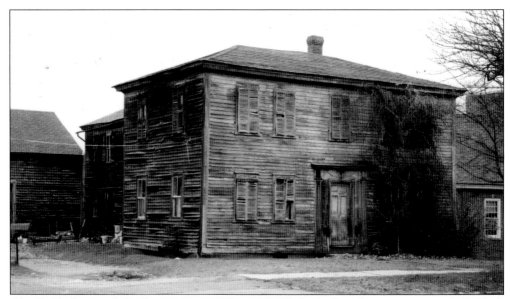

Abijah Clark owned this house from 1855 to 1857. He built the adjacent store in 1845. Clark probably lived here before he built the Greek Revival house at 2 Brigham Street, later the home of Rev. John M. Stowe, who wrote the *History of Hubbardston* in 1881. This house at 3 Main Street was also known as the Huckins house. In the 1940s, there was a barbershop in the front south room and a back room where men would get together and play cards. The cigar smoke was said to be so thick in there that children were not allowed in. (Courtesy of HHS.)

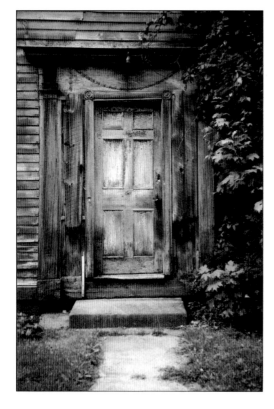

This old doorway graces the front of Clark's house at 3 Main Street, built around 1814, also known as the Huckins house. It is a fine example of a Federal-period home. (Courtesy of HHS.)

Before the age of the automobile, a community had to be quite self-sufficient. By the 1890s, Hubbardston had a long list of local businesses that supplied the consumer needs of its people, including an auctioneer, baker, blacksmith, boot shop, shoemakers, box makers, butchers, carriage makers, a doctor, a dentist, the American Express Company, and general stores that sold everything from grain, coal, and stoves to butter, cheese, and many other things grown, raised, and manufactured. (Courtesy of HHS.)

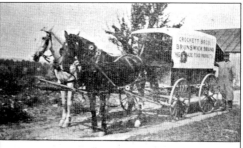

L. C. Crockett,   C. S. Crockett.

## Crockett Bros.

Dealers In

### Meat, Provisions, and Groceries.

Canned Goods,  Teas,  Coffee, Spices,  etc.

Tel. Conn.

HUBBARDSTON, MASS.

The town's first permanent post office building was erected on Main Street opposite the library at a cost of $30,000. It was dedicated in June 1962. (Courtesy of HHS.)

This building on the corner of Main and High Streets is where the GFA Credit Union is now located. It was a general store and residence owned by William Merrifield Clark and Jennie Young Clark. William ran the store until he died in 1941, and then his wife, Jennie, took it over. The property was purchased by Dr. Donald F. Lytle and torn down. There were hay scales and a gasoline pump in the front of the store. (Courtesy of HHS.)

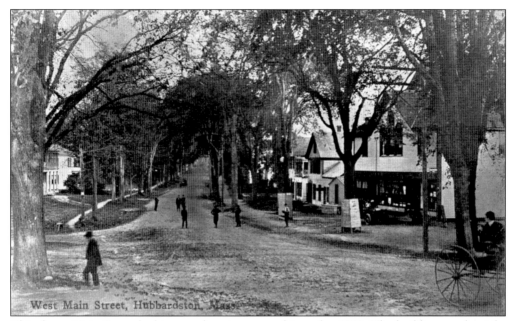

This shows Main Street looking south as it appeared just after 1900. The building on the right is where the present-day Mr. Mike's store is located. There was a dance hall upstairs where the Finns held dances on Saturday nights. This building, along with many others, was destroyed in the great fire of 1929, which was caused when a cigarette was tossed into an outhouse in the back. (Courtesy of HHS.)

This is the old highway barn that was located on the corner of Main Street and High Street where Charles Clark corner, or Millennium Park, is now located. In the 1920s, Charles Marean ran a Ford dealership here. (Courtesy of HHS.)

Built in 1803, this house, historically known as the Jacob Waite Inn, is still located on the southwest corner of Main and Elm Streets across from the Wheeler Brothers General Store. Waite was born here in 1775 and lived here until his death in 1818. The house was built to be an inn. By the late 1830s, Ethan A. Greenwood's Star Hotel and the Crystal House, which were much bigger inns, provided strong competition. (Courtesy of HHS.)

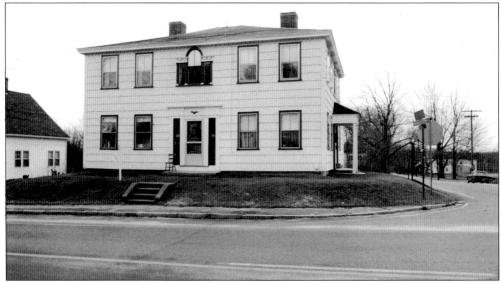

The upstairs of this house once contained a ballroom, but when Hobart Clark's family lived there, it was cut up into individual bedrooms, as he had a family of 15. Clark had a dental office in a room on top of the stairs on the second floor. Walter Norberg purchased this house in 1939, made it into a two-family home, and rented it to his future bride. In later years, it was made back into a single-family home. (Courtesy of Jane McCauley.)

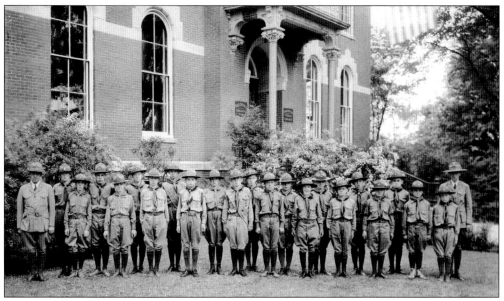

Shown here are the Hubbardston Boy Scouts in 1933. From left to right are (first row) scoutmaster Alton Clark, Albert Shaffer, James Meagher, Bernard Clark, Edwin Nurmi, Robert Coffin, George Stone, Matthew Nolan, David Bumpus, Weikko Holopainen, William Wheeler, and Earl Meagher; (second row) Weikko Mackie, Lester White, Donald "Chick" Wead, Gordon Clark, Paul Wasserbach, Charles Healey, Eero Ahola, Curtis Bumpus, George Lovell, Bill Sargent, and assistant scoutmaster Llewelyn Brewster. (Courtesy of HHS.)

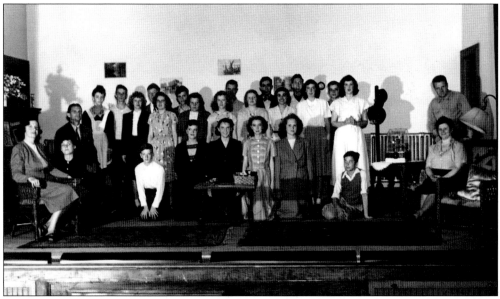

Hubbardston had a dramatic club in the 1950s. From left to right are (first row) Maria Hillman, Betty Douglas, David Dow, Jean Newcomb, Patricia Coffin, Nancy Howlett, Dorothy Woodward, Robert Suojanen, and Amy Hubbard; (second row) Mr. McClatchy, Lorna Lyon, Joan Lovewell, Elsie Coffin, Helen Wironen, June Newcomb, Barbara Green, Lenore Murdock, Carmen Woodward, and Shirley Woodward; (third row) John Adams, Kenneth Green, Charles Suojanen, William Hubbard, Harold Clark, William Suojanen, and Hammond Douglas. (Courtesy of HHS.)

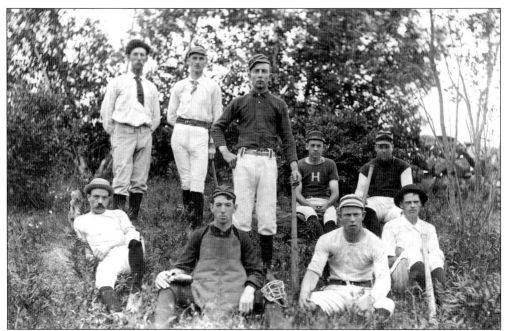

This was the Hubbardston Baseball Association in 1889. From left to right are (first row) Fred Beauregard, third base; Fred Parker, catcher; Charles Hallock, pitcher; and Tyler Bishop, center field; (second row) Gilbert Flagg, second base; Arthur Huckins, left field; Henry Hallock, first base; William Coffin, right field; and William G. Clark, shortstop. (Courtesy of Sylvia Thompson.)

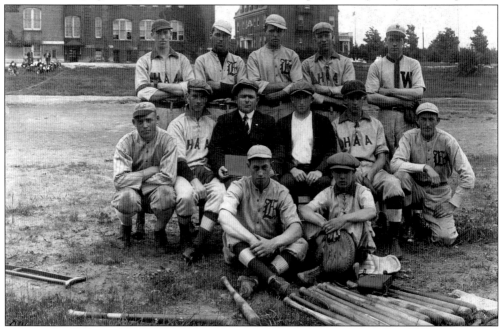

Hubbardston's baseball team is shown in front of the Gardner State Hospital in 1916. From left to right are (first row) Carl Clark and Leonard Clark; (second row) Chester Bemis, Joseph Valley, John Cunningham, Lyman Woodward, Matt Nolan, and Albert Butler; (third row) "Brownie," Richard White, Willard Slade, Bill Hallock, and Alton Clark. (Courtesy of HHS.)

# Two
# THE COUNTRY ROADS

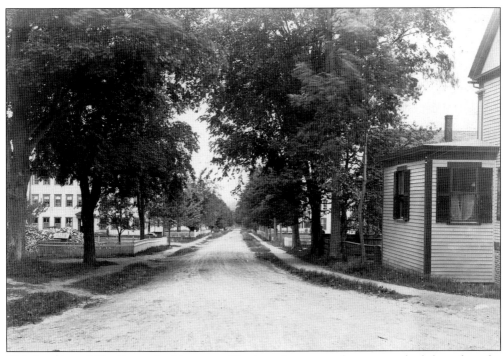

This is a view of Elm Street, looking west. The boot factory can be seen on the left, and on the right is an extended section of the Wheeler Brothers General Store, where the first telephone office was located. Shortly thereafter, the telephone office was moved to the residence of William H. Wheeler and his daughters Katherine, Bessie, and Mildred Wheeler on the upper end of Main Street. The first telephones were installed in June 1904 at the Wheeler's store, the Boston and Maine Railroad station, and the Cunningham farm. (Courtesy of HHS.)

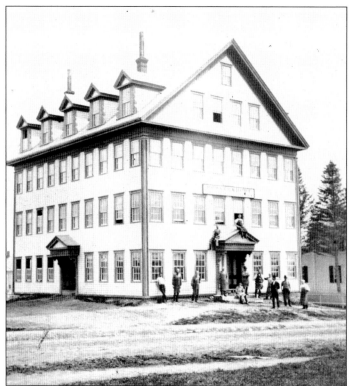

The boot shop on Elm Street was built about 1871 and changed hands several times. It was called the Bowker and Howe Boot Shop and later the Morse Boot Shop. In 1880 and 1882, Samuel S. Gleason was treasurer of the corporation. In 1926, Silas Wheeler, William Morse, and William H. Wheeler owned the business. (Courtesy of Alden Adams.)

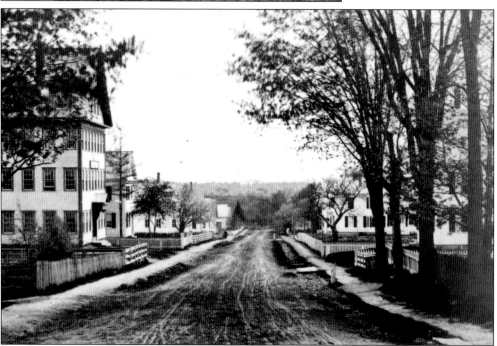

This is Elm Street looking west, showing the boot shop on the left. In later years, chairs were caned in this shop. In 1931, the building was dismantled, and some of the salvaged lumber was used to build the farmers' cooperative building on Main Street. (Courtesy of Alden Adams.)

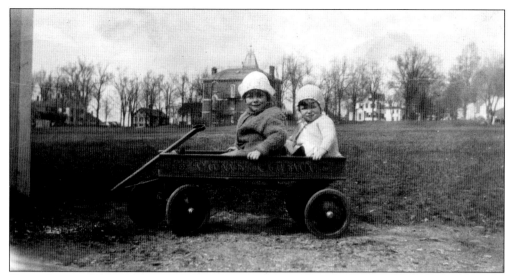

This is Leonard Field, a tract of land behind the town library that Jonas Gilman Clark donated to the town for recreation. Here are Curtis and Velma (Marean) Rivers enjoying an afternoon of play. Notice that the Hubbardston Center School had not been built there yet. This field is the site of the present-day grammar school that opened in September 1939. (Courtesy of Velma Rivers.)

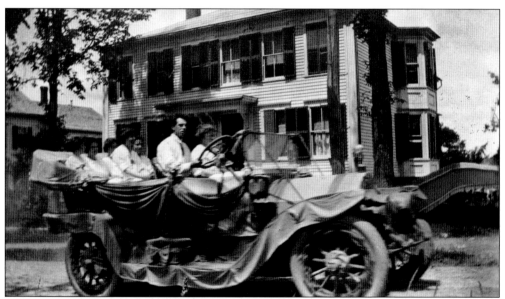

The Ephraim Mason house at 10 Elm Street was built in 1795 and was originally located on Main Street where the Jonas Gilman Clark library and town complex are today. This house was one of a group of buildings in this area owned by Clark that he moved in 1870 in order to clear a large lot on which he could have "a well-positioned library building" constructed. He donated the building to the town in 1874. This house appears to have been an inn during the early 19th century. The old car was in a Fourth of July parade about 1914. (Courtesy of HHS.)

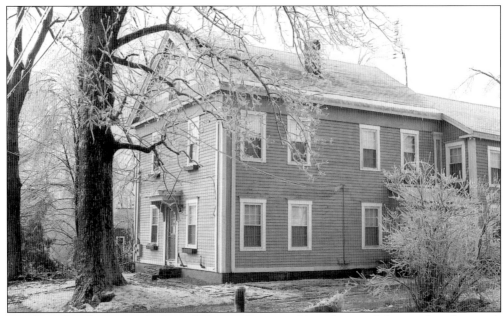

The first schoolhouse was built in 1770 near the central burial ground. It served as the town's meetinghouse until the First Parish Church was built in 1773. As the population grew, the town was divided into districts, each providing a building and support for local schooling. This house, now 14 Elm Street, became Hubbardston's School No. 1 in 1831. The building was originally set farther back before Jonas Gilman Clark moved it closer to the main road. (Author's collection.)

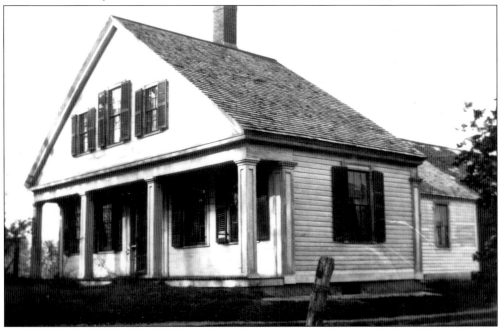

Herman Rivinoja, a Finnish immigrant married to Hilda Paananen, bought this house on Barre Road in 1923. The Rivinojas later bought 33 acres across the road that included a barn and kept chickens and a few cows. Rivinoja died in 1979 at the age of 96. Barry and Kathleen Heiniluoma have lived in the house since 1980. (Courtesy of Velma Rivers.)

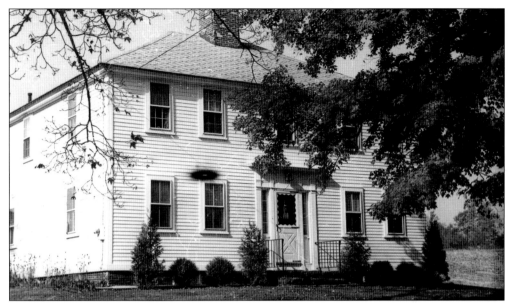

This Federal-style house on Barre Road was built in 1815. In 1885, this house was owned or occupied by William Gates Clark, a chair maker. In 1860, Micajh Reid owned the property, followed by William H. Stowe, who lived there until 1887. Later it was owned by Austin Brown from 1887 to 1897 and Morgan Memorial from 1914 to 1938. After a brief ownership by John and Anna Johnson, Alfred and Amanda Markula bought the house in 1941. Currently called Windrose Farm, it is owned by the Berthold family. (Courtesy of HHS.)

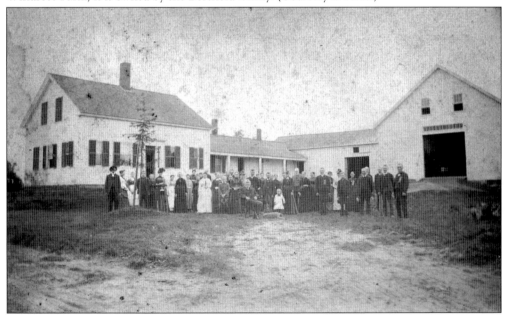

Clover Ridge Farm on Barre Road includes a modest Greek Revival farmhouse, built in 1850. John D. Holopainen and his wife, Amanda Kangas Holopainen, bought the farm in 1918. They made it one of the most prosperous and progressive dairy farms in the area. Their son Weikko took over the farm in 1949. Their oldest son, Waino Holopainen, an inventor, developed the world's first hydraulic backhoe in 1948 with his partner, Roy Handy Jr. (Courtesy of HHS.)

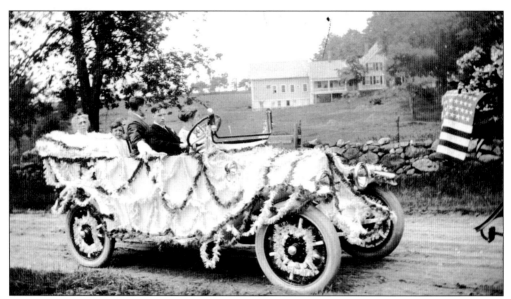

Before English settlers came to Hubbardston, a preexisting Native American trail is said to have passed where Parsons Road was later laid out; the trail wended south of Mount Wachusett, along Old Princeton Road, and eventually onto Burnshirt Hill. Eleazer Brown and his wife, the first known settlers of English descent in Hubbardston, built an inn near or on this house lot seen in the background in 1737. Brown was offered 60 acres of land if he provided hospitality to travelers for seven years. These photographs were taken during a Fourth of July parade in 1914. (Courtesy of HHS.)

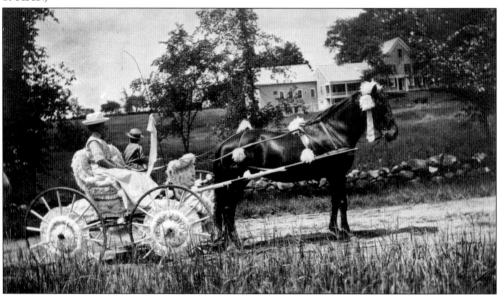

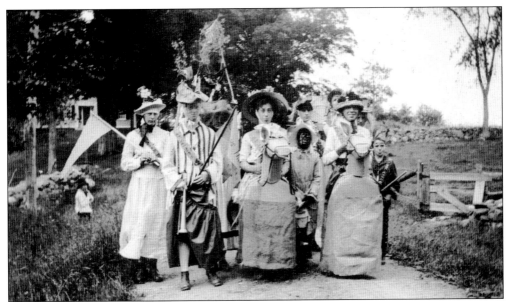

These folks on Parson Road are all dressed up for the Fourth of July parade in 1914. Social events such as this played a major role in Hubbardston's community activities. (Courtesy of HHS.)

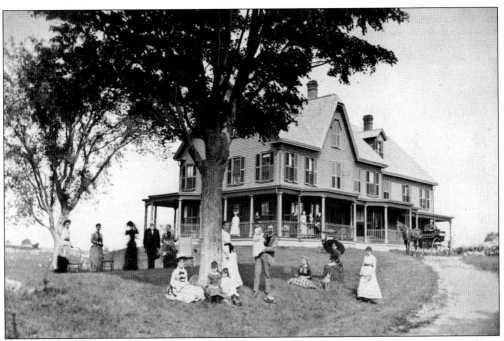

This is how the Cunningham farm on Old Westminster Road looked before the Metropolitan District Commission (MDC) tore it down, along with many other farms and private residences, to protect watershed land. There were several mills that the MDC took over through eminent domain that used the water to power their mills. Approximately 47 percent of Hubbardston is owned by the MDC, now known as the Department of Conservation and Recreation (DCR). With all the unspoiled forest, lakes, and streams, hunters and fishermen are attracted to the area. (Courtesy of HHS.)

This is the Allen farmhouse on Morgan Road. The house was later owned by Paul B. Morgan of Worcester, and after the death of his oldest son, Philip Morgan, it was owned by Phillip's widow and two sons, Paul Morgan of Shrewsbury and Peter Morgan of Leicester. This photograph was taken around 1903 from the southeast side of the house. Mr. and Mrs. Michael Como now own the house. (Courtesy of Harley Edwards.)

Paul B. Morgan purchased the Morgan farm around 1910. He came from Worcester and was the owner of the Morgan Construction Company. Harley Edwards, one of Hubbardston's most noted citizens, managed the farm from 1929 to 1968, when the Morgan family sold it to Alfred N. Whiting of Worcester. During those years, the farm boasted a fine dairy herd. (Courtesy of HHS.)

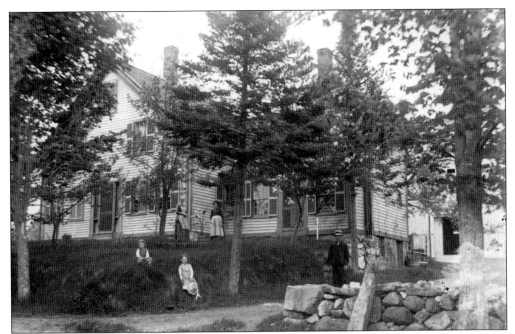

The Morgan family had compassion for Hubbardston and its people when things became difficult during the Great Depression. Local residents were hired to cut timber, earning 35¢ an hour in 1934. The Morgans also hired children from town to work on the farm, performing the many chores of planting, weeding, and picking berries. (Courtesy of HHS.)

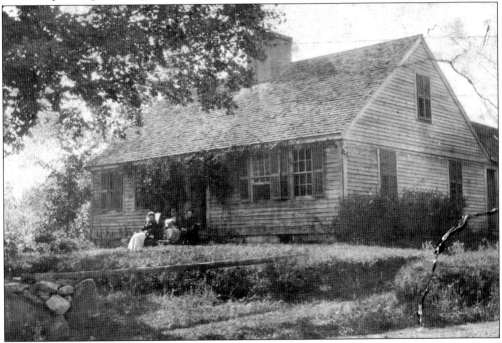

This is the Joseph Grimes homestead on Old Westminster Road on the northern corner of Grimes Road. It is believed to be the oldest house in Hubbardston and was built in 1789. However, it was torn down and moved. (Courtesy of HHS.)

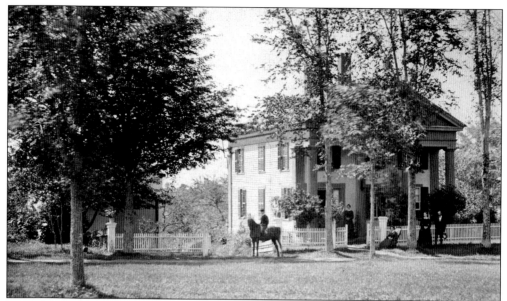

Rev. John M. Stowe was a Hubbardston native born in 1824. As a young man in Hubbardston, he was active in the lyceum and taught school. He graduated from the Bangor Theological Seminary in Maine in 1854 and was ordained in Walpole, New Hampshire, in 1855. The Evangelical Congregational Church installed him as minister in 1874. Shortly afterward, he moved into this house at 3 Brigham Street. (Courtesy of HHS.)

Stowe undertook to write a town history, using notes of former town clerk William Bennett. This work had not been completed at the time of his accidental death in 1877, when he was thrown from a wagon. His wife, Sarah Stowe, completed the work, using his notes. The book *History of Hubbardston* was published in 1881. She remained owner of the house until 1918. (Courtesy of HHS.)

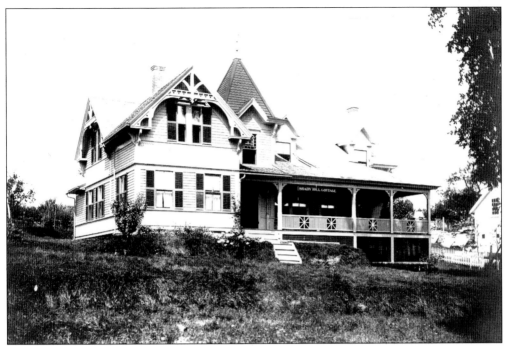

Frank Benjamin Coffin built this house, which is now on Brigham Street, in 1889. Eben Moulton Coffin and Thomas Tristam Coffin moved to Hubbardston in early 1872. Eben bought a sawmill on the lower end of Mason Brook in 1880. It was known as the Coffin Mill. The fancy millwork inside and outside of this house was produced at the mill. (Courtesy of HHS.)

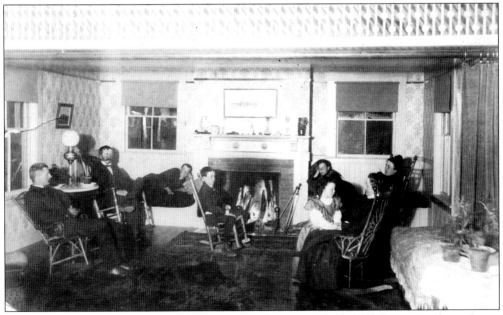

This is the living room in the Coffin house, also known as Shady Hill Cottage and now home of the Frateschi family. Pictured are Henry Browning, Fred W. Blackmer, Ralph or Albert Blackmer, Waldo Blackmer, Bernice Blackmer, Mrs. Henery Blackmer, and Madge Blackmer. The photograph was taken about 1900. (Courtesy of HHS.)

Edward S. Bennett, a Hubbardston native born in 1847, married Clara Gates in 1884 about the time they bought this house at 9 Brigham Street. In 1897, they made it into a guesthouse called Merrymont House, which was open year-round until his death in 1933. The guests could enjoy a splendid view overlooking Brigham Pond. (Courtesy of HHS.)

**MERRYMONT HOUSE,**

*E. S. Bennett, Prop.*

Special Attention Given Summer Guests.
Modern Conveniences.   Open All The Year.

Tel. Conn.

**HUBBARDSTON,    MASS.**

Here are some cows out on pasture at 9 Brigham Street. Even living close to the center of town, most families had a few cows or chickens for their own use. Everyone had a garden where they grew vegetables to be stored for use in the winter months. (Courtesy of HHS.)

There were a lot of community events where there was competition over who had the biggest pumpkins or best-tasting apple pie. Every town held fairs where there were cattle shows and fun and games for children and adults alike. (Courtesy of HHS.)

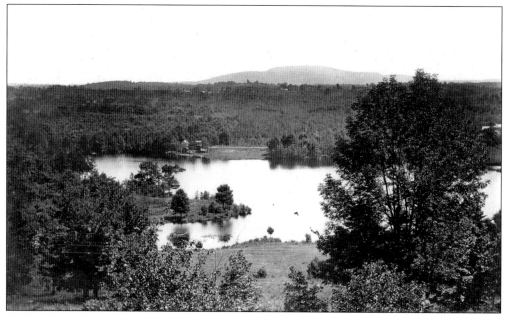

Hubbardston lies in the midst of the rolling hills of central Massachusetts. There are many splendid views with a backdrop of either Mount Wachusett or Mount Monadnock. The view above is looking down at Brigham Pond, with Mount Wachusett in the background. Brigham Pond offered swimming and boating as well as a place to go ice-skating in winter months. (Courtesy of HHS.)

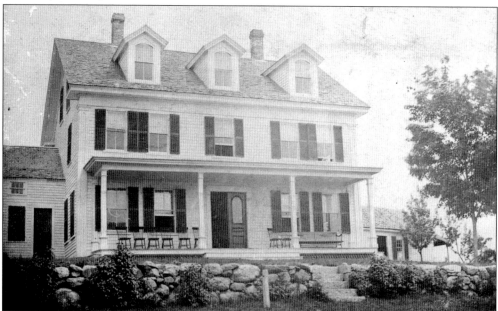

Cathedral farm on Old Princeton Road is an outstanding surviving example of Hubbardston's resort activity in the late 19th and early 20th centuries. It was built in the 1880s by a local family as a guesthouse and later remodeled by successive owners for use first as a sanitarium and then a resort. Wachusett Rest, the farm, was bought in 1920 by St. Paul's Cathedral in Boston as a resort for families in the church who could not otherwise afford a rural vacation. (Courtesy of HHS.)

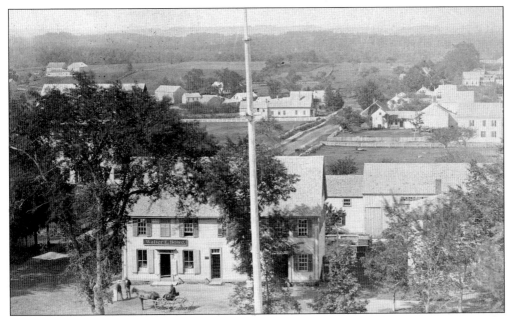

This is a view of the Wheeler Brothers General Store taken from the Unitarian church steeple. However, at the time this photograph was taken in 1871, it was known as the Walter E. Howe General Store; the Wheeler brothers did not buy it until 1875. It stayed in the Wheeler family as a general store up until 1968, when Silas Wheeler retired. His son Silas Morrison Wheeler Jr. lived there until 2001, when the store and its contents were auctioned off. (Courtesy of HHS.)

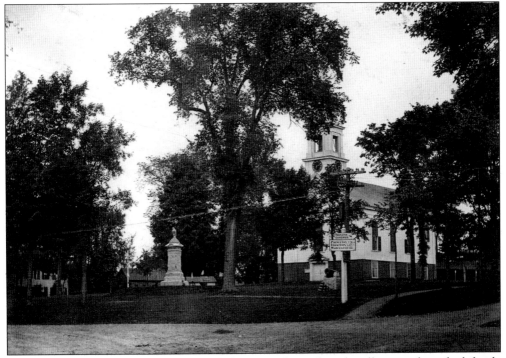

This view of the common from the end of Elm Street shows the sidewalk going along the left side of Brigham Street and the buggy shed behind the Unitarian church. (Courtesy of HHS.)

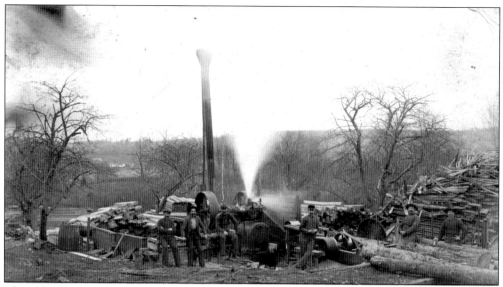

The old mills were dangerous places. On April 11, 1871, while sawing lumber at the steam mill of William Bennett, Levi Hartwell was so severely injured by a board thrown from the saw that he died a few hours later. This photograph was taken in 1906. (Courtesy of Velma Rivers.)

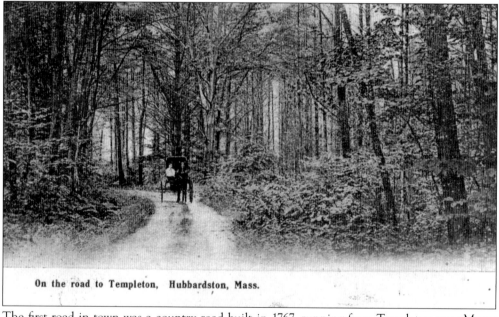

The first road in town was a country road built in 1767, running from Templeton over Muzzy Hill, through the center of town, and into Rutland. Above is a traveler on the road to Templeton. (Courtesy of HHS.)

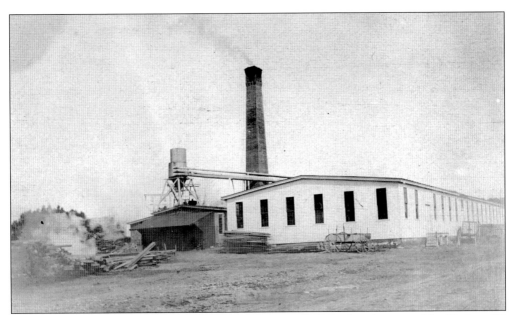

One of the town's biggest industries was the Howe mill, owned and operated by Herbert W. Howe. In 1869, he bought out his father's lumbering business and joined with a series of partners, including S. S. Gleason of Gardner and Fred E. Pollard, to create a lucrative business. It was a lumber mill located on the north end of Brigham Pond. However, the building was destroyed by fire on May 22, 1895. (Courtesy of HHS.)

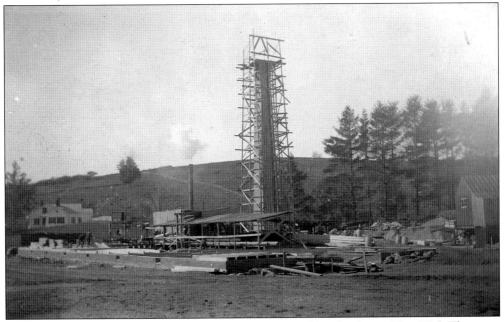

Here is the Howe mill being rebuilt after it was destroyed by the fire in May 1895. The main building was 48 feet by 176 feet and was located on the south side of Brigham Pond. It was also known as the Hubbardston Chair Factory. Howe himself played a prominent role in town affairs, serving as a selectman and representative to the Massachusetts legislature in 1889. (Courtesy of HHS.)

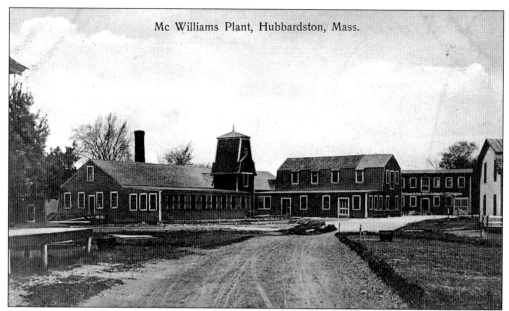

The McWilliams mill was located on what is now DCR land south of the center of town on Route 68. It was formerly the W. Wilber and Parker's saw- and gristmill. Arthur McWilliams manufactured wooden goods here in the late 1800s. The company was later known as the Star Blanket Manufacturing Company. This company was responsible for making Evergreen Road a through street so there would be a better access to the railroad station. (Courtesy of HHS.)

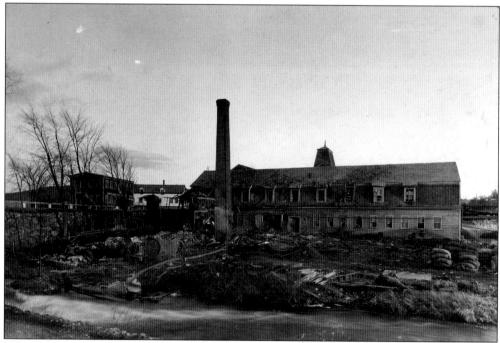

The Hygienic Blanket Mill, which made horse blankets, had an explosion in 1907 that destroyed the building. It reopened in 1909. The business changed hands a number of times before it was purchased by the MDC in 1929. (Courtesy of Velma Rivers.)

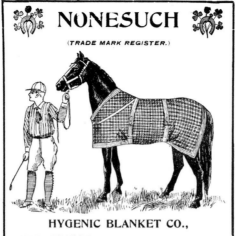

Before the age of the automobile or before they were affordable for the general public, anyone who traveled took the train or went by horse and buggy. Most everyone had livestock of one kind or another. Having a horse or two in the barn was no real burden because they went out to feed the cattle, goats, pigs, or chickens anyway. Hubbardston, like any community, had a large horse population, so at this time in history, a hygenic horse blanket was a practical product that everyone could use. With the advent of the automobile, there was less need for such a product. Hubbardston's last dairy farm is now closed, but there are a few horse stables springing up that sponsor shows and computation as well as rent out stable space and livery. In cold weather, the horses outside are wearing such blankets. (Courtesy of HHS.)

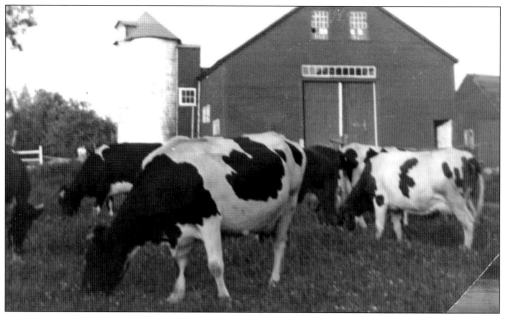

Hubbardston had a number of small dairy farms with an average of 20 to 35 cows each. The big farms such as the Slade, Burnshirt, and Breezy Hill Dairies bought milk from these small farms and distributed it under their own label. This is the Richard farm at 130 Gardner Road that Frank A. Richard purchased in 1948 from Matti Lappi. The Richards raised Holstein and Guernsey cattle. (Courtesy of Louis Richard.)

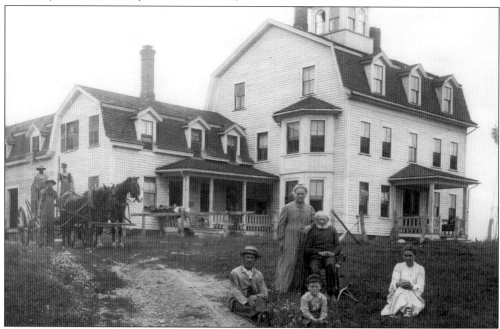

Edwin S. Bennett, inventor and farmer, built this lovely farmhouse on the crest of Mount Jefferson. However, it was destroyed by fire. The foundations are still visible in a grove on the west side of the road. It was also known as the Gates mansion. The acreage surrounding the site was purchased by the town as green space for recreation. (Courtesy of Hubbardston Historical Commission.)

# Three
# HEALDVILLE

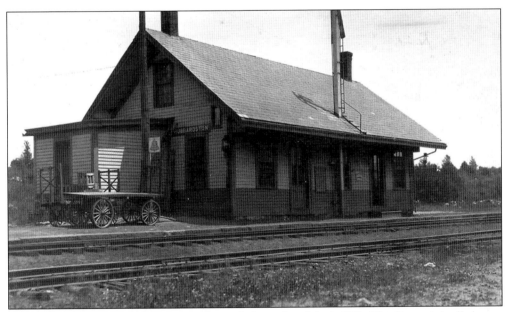

The railroad came to Hubbardston and was dedicated on July 4, 1871. This line originally began as the Boston, Barre and Gardner Railroad. It was the result of a desire to build a railroad line from Worcester to Gardner. The planning for all this started as early as April 1847. In later years, this efficient mode of transportation opened more job opportunities, where even without owning a car, one could work out of town. (Courtesy of Velma Rivers.)

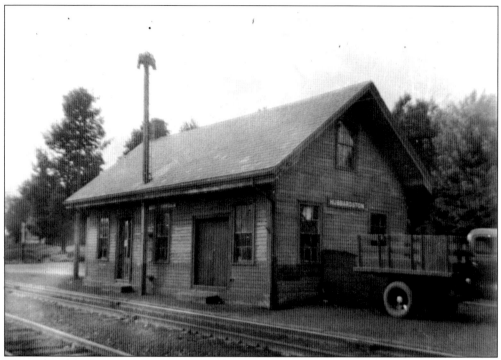

The railroad had a major impact on Hubbardston when it came into operation in 1871. The change was both good and bad, as it linked the local mills and farmers with outside suppliers of raw materials and was a means of exporting their products and produce to distant markets. However, the hotels and inns suffered as passengers traveling north and south could go much faster and did not have to go through town on the much slower roads. (Courtesy of HHS.)

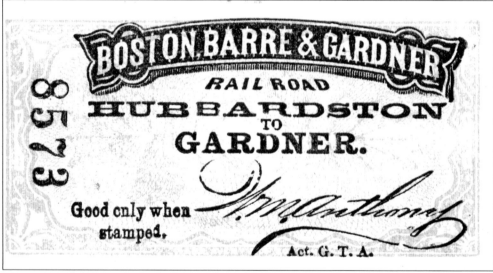

This is an early train ticket from the Hubbardston railroad station when it was the Boston, Barre and Gardner Railroad, stamped July 19, 1884. Children could walk to the depot and take a train into Gardner to see a movie or visit a friend or relative. There was also a shuttle service where one could get a buggy ride from the center of town to the station. (Courtesy of Velma Rivers.)

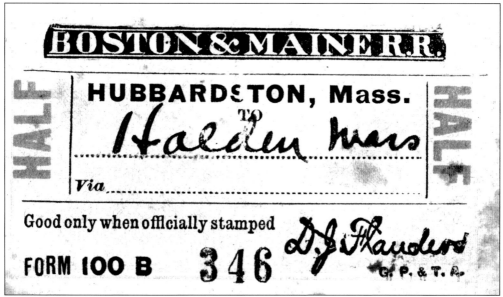

This is a train ticket stamped in 1912, when the rail line was incorporated into the Boston and Maine Railroad network. Milk and other fresh farm produce were shipped to markets in the cities. Blueberries grown in Hubbardston were shipped to Boston in large quantities by train. The Hubbardston station closed in 1955. (Courtesy of Velma Rivers.)

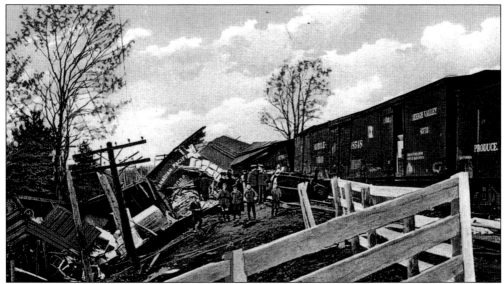

This is a wreck near Hubbardston involving a train carrying freight and produce. Hubbardston had many dairy farms that sold milk for mass distribution. There were several pickup stations where milk was collected and transported daily to be pasteurized and bottled. The farmers in Healdville brought the milk to the railroad station, while the farmers in the Pitcherville area brought it to the end of Pitcherville Road, where it was collected and transported to Gardner. (Courtesy of HHS.)

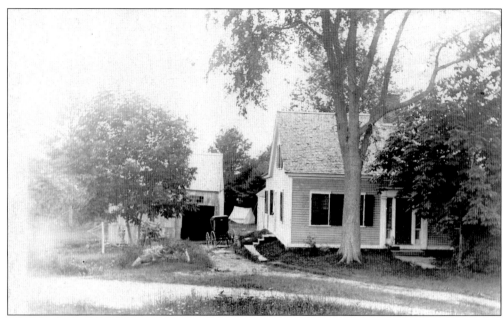

Here is a private home in Healdville when a horse-drawn buggy was used to travel around town. The railroad station was nearby where one could take the train to union station in Gardner and then transfer to a trolley to get around town. From stations in Gardner and Holden, one could go just about anywhere and return to Hubbardston without traveling on rough and unpaved roads. (Courtesy of HHS.)

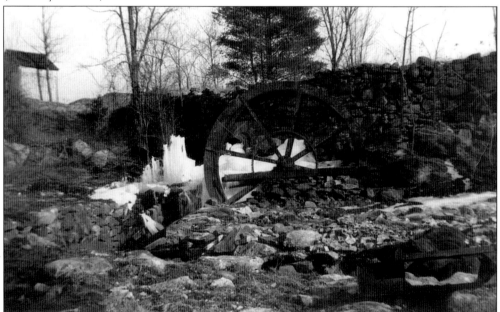

Healdville was a popular location, since the railroad from Providence, Rhode Island, to Keene, New Hampshire, provided excellent outside access. Around 1890, George B. Wilbur came to Healdville from Newton and established Wilbur's Tack Factory, which produced nails and tacks until 1923, when under the ownership of Roscoe Wilbur, it was sold to the MDC and shut down. (Courtesy of Hubbardston Historical Commission.)

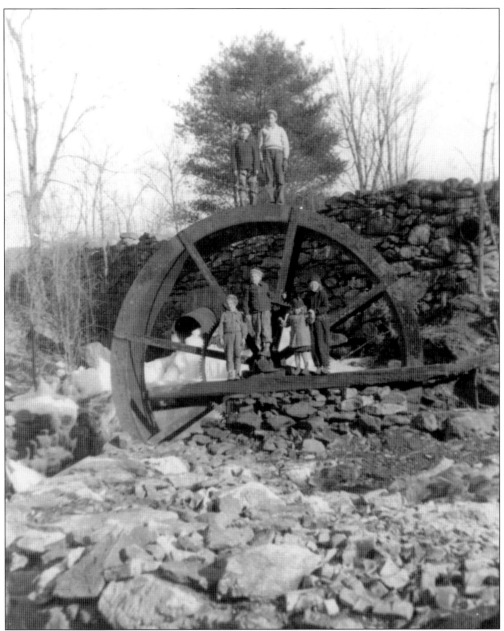

This waterwheel was 15 feet in diameter. All handmade, it took one whole winter and spring to build. The steel was cut by hand with a cold chisel, and holes were drilled by hand. The buckets were heated and formed in a blacksmith's forge. It was then put together with hot rivets, spokes were installed, and bearings were attached on each side of the wheel. Finally, the wheel was set in place to power the mill. As well as powering the many machines in the mill, the diverted water was also used to power a direct current generator. In the ceiling of the mill there were different-sized pulleys, so the size used determined the speed at which each machine would run. The waterwheel outside turned a main shaft along the length of the building where these pulleys were located, so several machines could be running at the same time and at different speeds. (Courtesy of Charles Clark.)

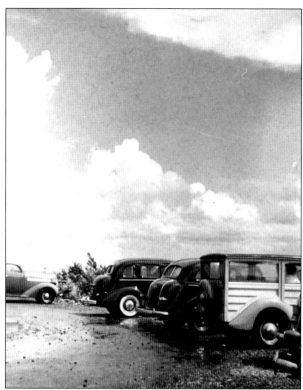

The town of Hubbardston is in the shape of a diamond with a chip broken off on the east side. The chip is Mount Wachusett, where the town of Princeton claimed that land. Driving a car to the top of the mountain was always a breathtaking trip, with splendid views of the whole region spread out below. Here is a lineup of automobiles on the top of the mountain in 1938. (Courtesy of Velma Rivers.)

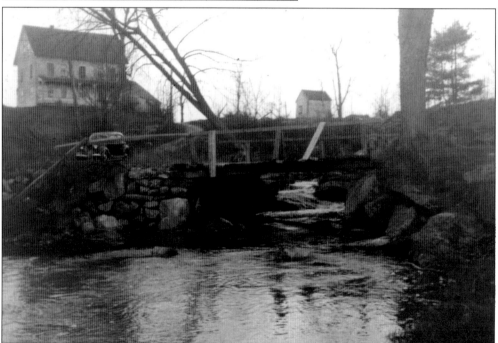

From the tack factory looking west, Mason Brook is flowing under the Healdville Bridge, where the moving waters continued downstream to provide power for several other mills, including the Coffin Mill, before pouring into Brigham Pond. (Courtesy of HHS.)

# COFFIN BROTHERS.

## MANUFACTURERS OF
## LOCK CORNER BOXES,
## TOYS & NOVELTIES.

### HUBBARDSTON,   MASS.

The Coffin Mill was built around 1850 by Levi Conant as an up-and-down sawmill, turning out chair rounds. He sold the mill to Joshua Woodland in 1883, and the manufacturing was changed to buttonhook handles and valve wheels. In 1885, Eben M. Coffin bought the mill, and it was called E. M. Coffin and Sons. It suffered a serious fire on April 1, 1902, and was rebuilt and improved. Coffin's son William ran the mill until his death in 1936. The mill was sold to the MDC in February 1938 and torn down. (Courtesy of David Simmerer.)

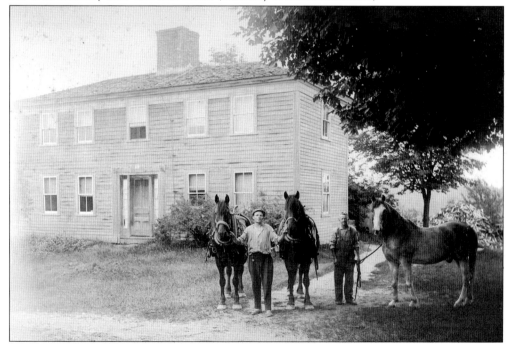

This house was located at 17 Twin Hill Road. Pictured are Edward V. Niemi (left) and John D. Holopainen. Hubbardston's horse population dwindled with the advent of the automobile, but in recent years, many stables have been built in town. (Courtesy of HHS.)

Oiva H. Rivers took this photograph around 1936 while driving on the Hale Road bridge before asphalt was laid down. Many of these old bridges were made of fieldstone and wood. Notice the tree trunks used for the guardrails. Traveling on these early roads was slow and treacherous under winter conditions. (Courtesy of Velma Rivers.)

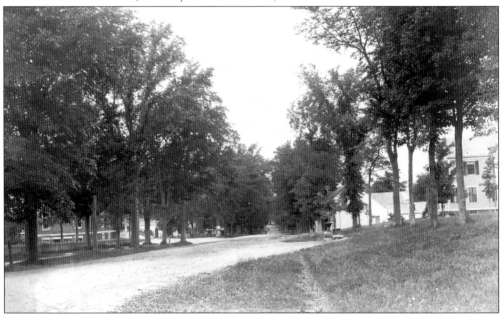

Here is a view of Main Street looking north when it was just a dirt road. To the left through the trees is the Jonas Gilman Clark library building, and to the right is the former Joseph Homans house that was built by Elwin Wheeler in 1892. When the roads were like this, traveling to Gardner or any surrounding towns usually was done on a Saturday or Sunday where most people worked in town. Those that did work out of town took the train. (Courtesy of HHS.)

# Four
# PITCHERVILLE

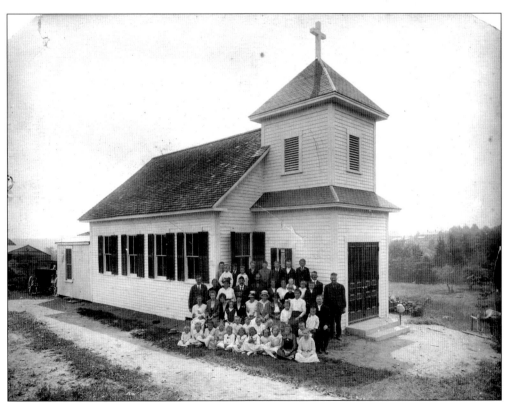

In July 1917, a group of the local Finns met at the home of Herbert Hooks in Pitcherville to discuss the construction of the Finnish Lutheran Congregational Church. Up until then, they had met and worshipped in private homes. Above is the first church they built, which was originally a private home. It was destroyed by fire on June 28, 1922. To the right in the distance is the house and barn of the Loukko farm. (Courtesy of Church in the Wyldewood.)

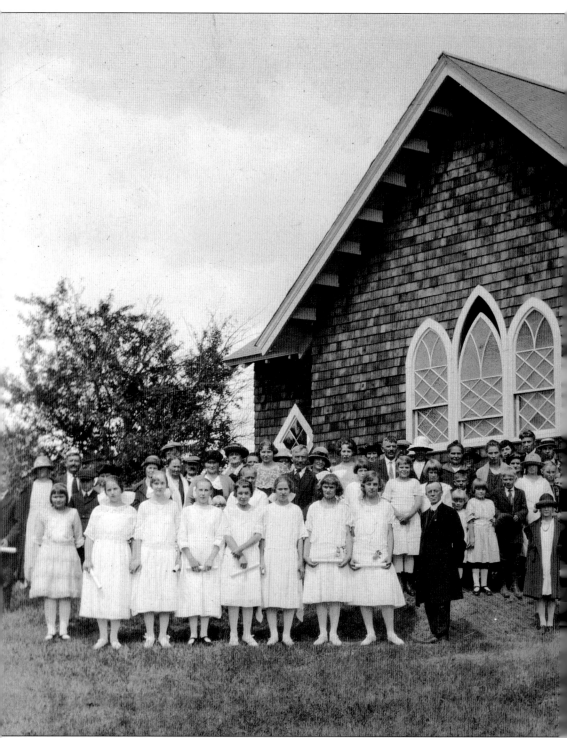

In 1923, the Finnish Lutheran Congregational Church was rebuilt. This photograph was taken on August 23, 1923. It was confirmation Sunday, and everyone was dressed up in his or her Sunday best. Rev. Alexander Kukko performed the service. Arthur Virta of Mission Street

Congregational Church of Gardner came to preach there, as well as Rev. William Sumner. The Finnish Lutheran Congregational Church was still going strong into the 1930s because of the older Finns' commitment to religious worship. (Author's collection.)

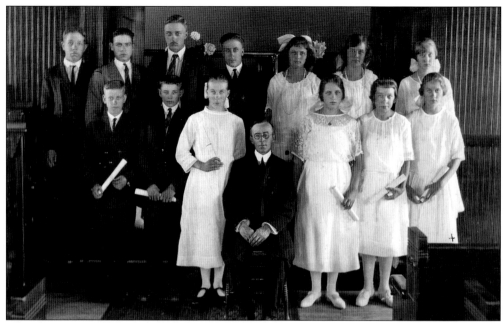

This photograph shows the youth of Pitcherville receiving their confirmation certificates on August 23, 1923. By the 1940s, membership had started to decline since the younger Finns did not have religious concern or commitment enough to maintain the church's vitality. However, the congregation did get together on Christmas Eve for many years into the late 1950s. (Author's collection.)

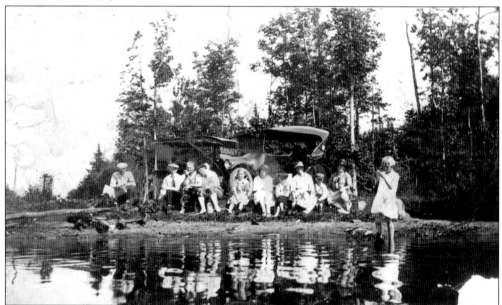

This is a Sunday afternoon picnic at the Pitcherville Pond after a church service at the Finnish chapel. The photograph was taken about 1917. Note the automobiles with ragtops. It has been said that the girls swam on one side of the pond, and the boys were on the other, as not everyone had swimsuits. This was also called Factory Pond because of the mills that were along its banks. The dam was washed out in the hurricane and flood of 1938. (Author's collection.)

One of the first Finns to come to Hubbardston was Asa Loukoo, who arrived on August 2, 1894. He came from Ohio and worked on the railroad in South Ashburnham. He purchased a 32-acre farm in Pitcherville for $1,000 and had a mortgage of $300. Around 1898 and shortly thereafter, more Finns came from Gardner and located in the Pitcherville area of town. Among the earliest Finns to settle in town were Herman Niemala and Kusti Mattila Heiniluomas in 1901. (Courtesy of Larry Kangas.)

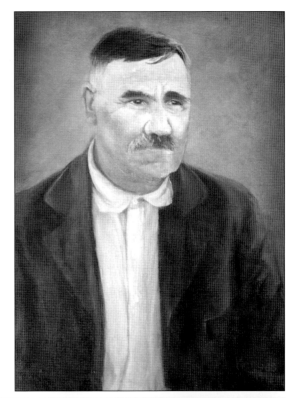

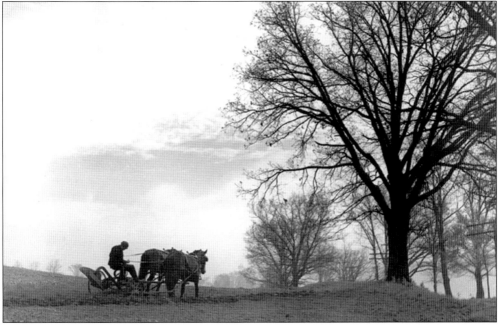

Many of the Finnish immigrants who settled here in Hubbardston bought farms that were run down and in desperate need of repair. With a lot of hard work and neighbors helping each other, many of these little farms proved to be quite prosperous. The photograph above shows spring plowing being done with a horse-drawn plow. (Author's collection.)

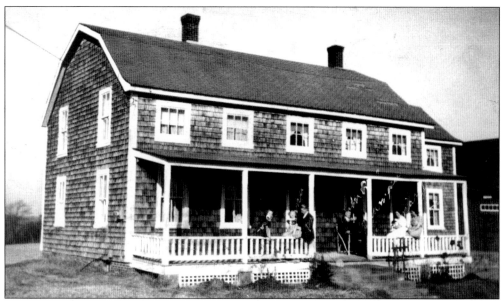

Asa Loukoo purchased this farm on August 2, 1894. Fire destroyed it in 1914, and it was rebuilt in 1915. Loukoo lived here until his death in 1942. His daughter Mary Loukoo took over the farm and lived there until 1946 when Waldemar E. Kangas, a grandson of Asa Loukoo, took it over when he married Dorothy M. Ronholm. They had five children, George, Esther, Larry, Nancy, and Gary. The farm had been in the family for 104 years when it was sold in 1998. (Author's collection.)

This is the deed showing that Asa Loukoo purchased the farm from Paul Halstrom in 1894. If Halstrom was of Swedish descent, Asa Loukoo could be the earliest Finnish immigrant to settle in Hubbardston. (Author's collection.)

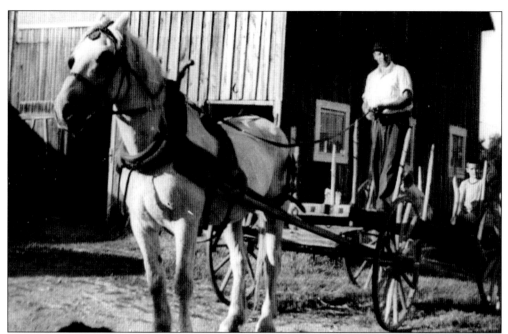

Here is Waldemar E. Kangas and his son George on the old buckboard wagon that his grandfather Asa Loukoo used to make dry good runs into town on Saturdays. The trip was an all-day affair, since they would talk with all the neighbors along the way. Sometimes the trip ended up at the South Gardner Hotel, where, if they got drunk, they were carried out into the wagon and woke up on Sunday morning in their own barnyard, where the "designated horse" had faithfully brought them. (Author's collection.)

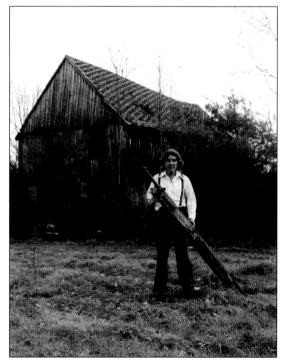

Here is Gary Kangas holding the front axle, all that remains of the buckboard wagon. Behind him is the barn at the Loukoo/Kangas farm. Like many old barns in Hubbardston, this one was neglected and had to be torn down. (Author's collection.)

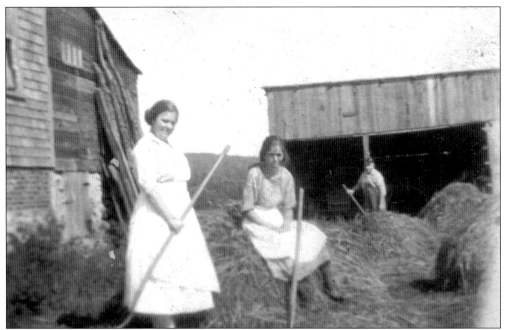

If hay that was cut, dried, and ready to go into the barn got rained on, it was turned over by hand to dry out before it could be put into the barn. Here are Asa Loukoo and his two daughters Lempi and Mary turning over hay. Notice the long dresses the ladies are wearing; it was a time when it was not customary for women to wear jeans or slacks. (Author's collection.)

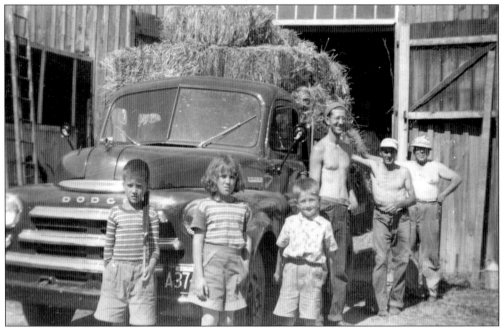

Hubbardston was primarily a farming community, where everyone in the family was involved in doing farm chores of one kind or another. Pictured from left to right are George Kangas, Esther Kangas, Larry Kangas, Lincoln Pervier, Waldemar E. Kangas, and John Albert Ronholm bringing a truckload of hay back to the barn. This photograph was taken before 1954. (Author's collection.)

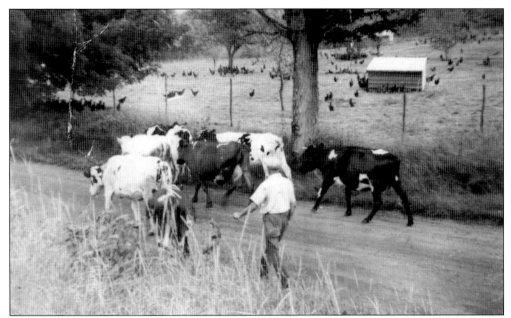

Here is Waldemar E. Kangas bringing the cows home from the church field, which was over the town line in Templeton. The field borders the land where the Finnish Lutheran Congregational Church was in Hubbardston on the town line. In the background are the chickens on the farm of Armas O. Karkane, located across the street from the Loukoo/Kangas farm. (Author's collection.)

This is the Benjamin F. Pierce house, built in 1840 at 63 Pitcherville Road. Pierce and Eda Coleman were married in 1843 and made their home here until Pierce moved his chair factory from Pitcherville to South Gardner. He sold the business in 1870, and in 1898, the house in Pitcherville was sold to S. D. Hough. This house was occupied by a succession of Finnish families. The most recent of these was Armas O. Karkane, who had two multilevel barns in which he raised chickens. (Author's collection.)

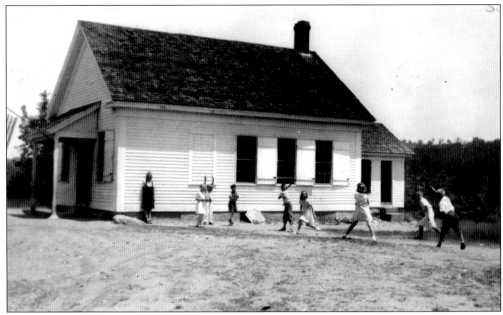

Hubbardston's No. 3 School was on the northeast corner of Route 68 and Morgan Road. Children walked to this school and whether one lived on Morgan Road or Pitcherville Road, there was always a hill to climb. For many, the walk was well over a mile. Children went to this school up to the sixth grade and then went to the old Center School on the east side of Main Street. These are the children of the No. 3 School. (Courtesy of HHS.)

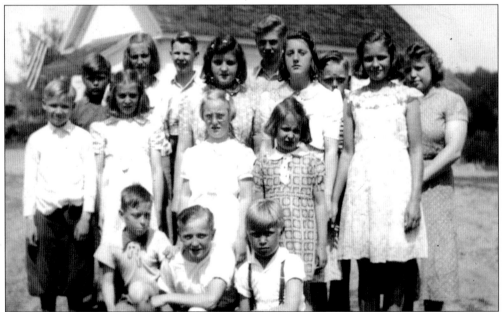

The 1939 class was the last one to go to the No. 3 School. Seen here from left to right are (first row) Douglas Penttila, Ivan Johnson, and Paul Leskinen; (second row) Waino Havumaki, Betty Niemela, Alma Sturtevant, and Elaine Edwards; (third row) Allan Leskinen, Helmi Johnson, Edna Johnson, Edith Johnson, and Helena Lappi; (fourth row) Donald Edwards, Robert Niemela, Richard Mattila, and Miss Kangas. (Courtesy of Aila Kangas Pushala.)

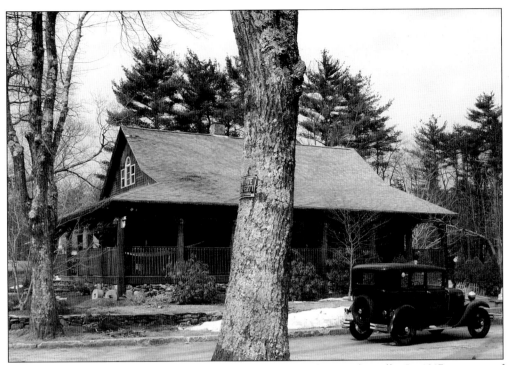

Many of the early Finns who came to Hubbardston settled in Pitcherville. In 1917, a group of Finns established the Finnish Farmers' Association. They built a meetinghouse at what is now 146 Ragged Hill Road and called it Finn Hall. To raise money for its construction, they had a tractor, taking turns plowing gardens for people in town, and they used a portable saw rig to cut people's cordwood for a fee. Today it is a private home with many changes to its architecture, including the addition of a wraparound porch. (Author's collection.)

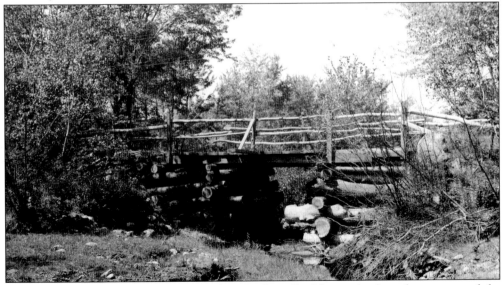

This is the bridge on the Birches Road in Pitcherville. Notice the logs that were used for support. This stream and the upper pond dam provided water that fed into the Pitcherville Pond. (Courtesy of HHS.)

# The Commonwealth of Massachusetts

**Be it Known** That whereas Aati Poikonen, Gustaf Mattila, Axel V. Havumaki, Evert Poyhonen, John Porka, Victor Asp, Charles Bjorbacka and Asa Laukoo

have associated themselves with the intention of forming a corporation under the name of The Finnish Farmers Society of Hubbardston,

for the purpose of establishing and maintaining a place or places for reading rooms, libraries or social meetings in Hubbardston, Massachusetts;

and have complied with the provisions of the statutes of this Commonwealth in such case made and provided, as appears from the certificate of the President, Treasurer, Clerk and Directors of said corporation, duly approved by the Commissioner of Corporations and recorded in this office:

**Now, Therefore,** I, ALBERT P. LANGTRY, Secretary of the Commonwealth of Massachusetts, DO HEREBY CERTIFY that said

Aati Poikonen, Gustaf Mattila, Axel V. Havumaki, Evert Poyhonen, John Porka, Victor Asp, Charles Bjorbacka and Asa Laukoo,

their associates and successors, are legally organized and established as, and are hereby made, an existing corporation under the name of The Finnish Farmers Society of Hubbardston, with the powers, rights and privileges, and subject to the limitations, duties and restrictions, which by law appertain thereto.

**Witness** my official signature hereunto subscribed, and the Great Seal of The Commonwealth of Massachusetts hereunto affixed, this sixth day of May in the year of our Lord one thousand nine hundred and twenty.

*Albert P. Langtry*
Secretary of the Commonwealth.
By _____
Deputy, Acting Secretary.

This is the original charter of the Finnish Farmers' Association of Hubbardston from 1920, signed by the secretary of the Commonwealth of Massachusetts and stamped with the state seal. The founding fathers were Aati Poikonen, Gustaf Mattila, Axel V. Havumaki, Evert Poyhonen, John Porka, Victor Asp, Charles Bjorbacka, and Asa Loukoo. (Author's collection.)

# Five
# WILLIAMSVILLE

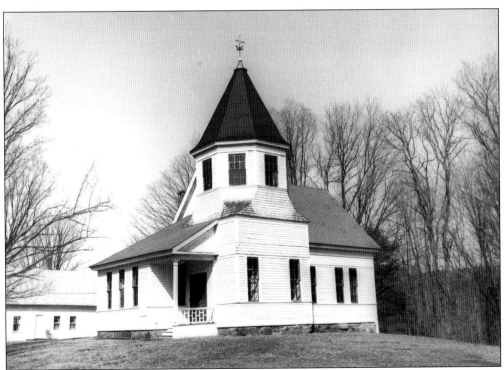

The idea for a chapel in Williamsville was conceived on August 16, 1888, during a meeting at the home of Seth P. H. Hale. This was the beginning of the Williamsville Union Sunday School Society. The chapel was built at a cost of $2,033 and was dedicated on February 22, 1889. In October 2001, to prevent further deterioration, the Williamsville Union Sunday School Society sold the building to the Hubbardston Historical Society for the sum of $1. (Courtesy of HHS.)

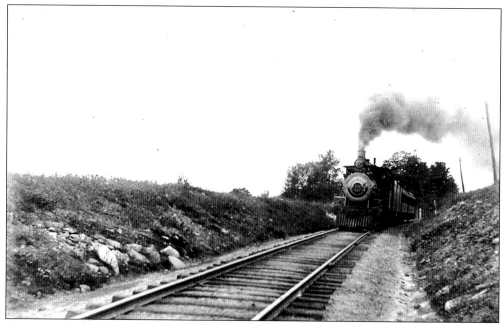

Construction of the rail line running through Williamsville that went from Palmer to Winchendon began in 1870. It was in full operation by 1883. The line gave the lumbering industry a means of exporting product to out-of-town markets. After the great hurricane and floods of 1938, the line for the most part was terminated. (Courtesy of HHS.)

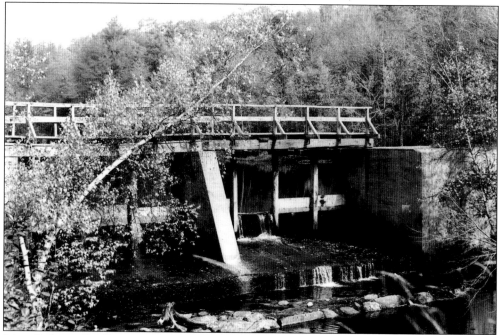

Like all the mill villages in Hubbardston, Williamsville also had its natural running streams where millponds were built to use the waterpower to run sawmills and gristmills. A lot of concrete was used in the construction of the dam shown here, which helped it survive the great floods of 1936 and 1938. (Courtesy of HHS.)

W. H. BOWDLEAR, President  GEO. R. WEIN, Treasurer
W. H. BAILEY, General Manager

# Williamsville Electric Co.

GENERATORS OF ELECTRICITY BY WATER POWER AT
WILLIAMSVILLE, MASS.

OFFICE, 220 DEVONSHIRE ST. Room 209
BOSTON, MASS.

Dec. 2, 1908.

J. E. McWilliam, Esq.

Hubbardston, Mass.

Dear Sir; Not having an opportunity of seeing you I write to suggest that you see if your town will erect the poles and string the wires for electric lighting, the same as the town of Templeton has done.

If they will do this, we will agree to furnish the electric current for less price than Templeton is paying, or than it can be had from any other source. Please consider this proposition and let me know if it is possible to bring it about, and oblige

Yours very truly,
Williamsville Electric Co.

Wm H. Bailey
Gen'l Manager.

The first electric power used in Hubbardston was generated in Williamsville in 1908. The Slade dairy on Hale Road was the first farm to use electric power in its operations. Over 5,000 people took a tour of this farm during its first year of operation. By 1910, there were electric lights on Hubbardston's Main Street. Shortly thereafter, the power came from the Gardner exchange. (Courtesy of HHS.)

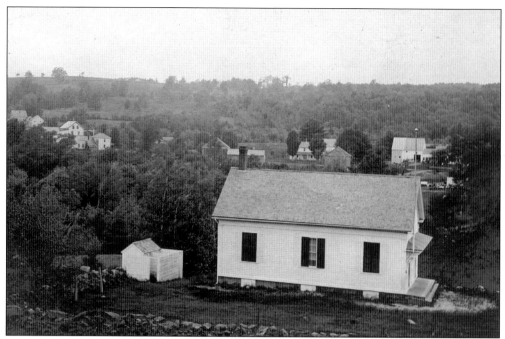

By 1849, Hubbardston took pride in the fact that it had 13 district schools, each of which was run on a nongraded basis with an average of 30 pupils each. This photograph shows Hubbardston's No. 8 School in Williamsville. (Courtesy of HHS.)

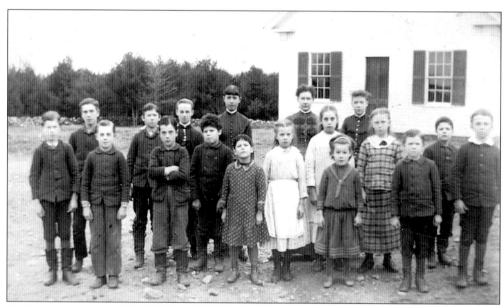

Hubbardston's No. 6 School was in the stone district on Old Princeton Road. This photograph was taken in 1885. The teacher was Carrie Grimes, and pupils shown here include Sid Waite, Arthur Waite, Luella Waite, Etta Sylvester, Mary Lanphear, Arthur Lanphear, Nellie Murdock, Edward Murdock, Harry Murdock, and Fanny Murdock. Since it was a one-room schoolhouse containing many grades, several members from the same family were taught together. (Courtesy of HHS.)

# Six
# THINGS REMEMBERED

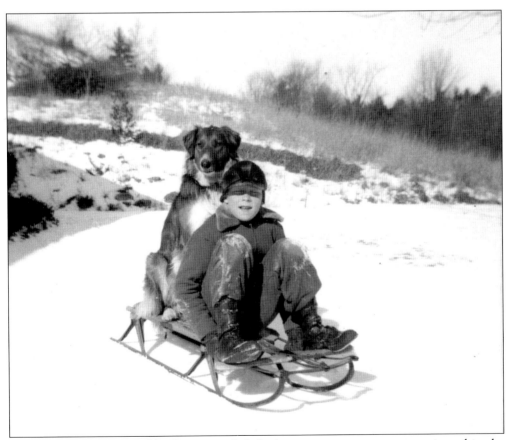

On February 16, 1943, Hubbardston recorded the lowest temperature ever experienced in the area. It was a bone-chilling 54 degrees below zero. This is Theodore Clark and his dog Boots enjoying a day on the slopes. (Courtesy of Velma Rivers.)

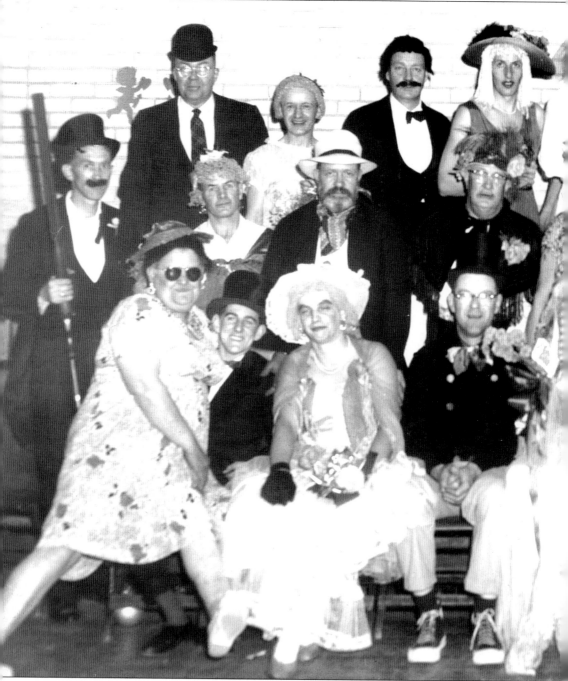

On February 12 and 13, 1960, members of the First Parish Unitarian Church presented two performances of a memorable and hilarious "Womanless Wedding," held at the Center School auditorium. It featured an all-male cast, with the "female" members of the wedding dressed in drag. Props included a ball and chain and a double-barrel shotgun, as it was a "shotgun" wedding. A roll of toilet paper was rolled down the aisle for the bride, Weikko Merikanto, to make his entrance. Pictured from left to right are (first row) Charlie Suojanen, Norman Oullette,

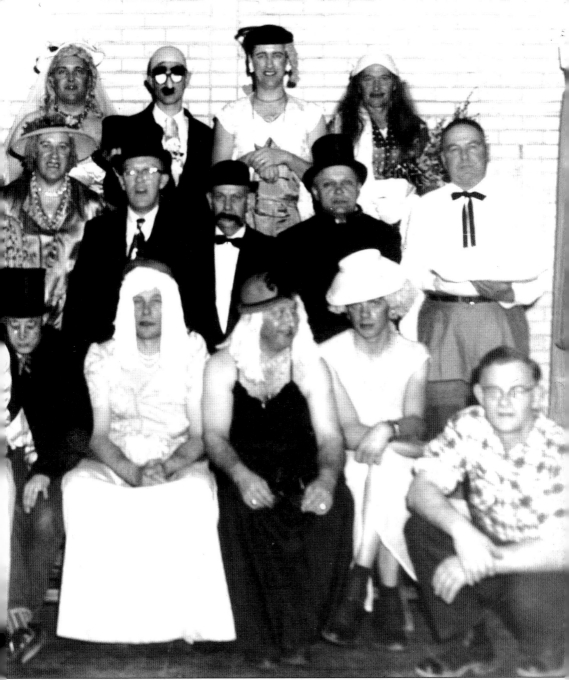

Richard Holgerson, Joe Stromski, Weikko Merikanto, Kenneth Roettger, Eino Olly, Wilfred "Fats" LaFrennier, Ray Clark, and Fred Watts; (second row) Roy Handy with shotgun, Waldemar Kangas, Russell Valley, Harley Edwards, Alton Clark, Jerry Poules, Norman Gallagher, Leonard Clark, Otto Laitinen, and Everett Woodward; (third row) Paul Blaisdell, Werner Schindler, Onni Kujala, Richard Lyons Jr., Walter Blyther, Sulo Salminen, Robert Hubbard, Rev. Lawrence McGinty, and Walter Norberg. (Author's collection.)

# NONE-SUCH STREET FAIR

Unitarian Church Grounds
Hubbardston, Mass.

## SATURDAY, JULY 18, 1959

10:00 A. M. till 9:00 P. M.

CHICKEN BAR-B-Q 4:30-6:30 p.m.
Door Prize
PUPPET SHOW 7:30 p.m.

Games of Skill - Rides - Fancy Work
Refreshments - Souvenirs - Fish Pond
White Elephants - Cotton Candy

To raise money to purchase an organ for the First Parish Unitarian Church, members sponsored a street fair in 1957. They had games of skill, a Finnish "coffee table," raffles, an antique and flower show, and many games and activities for children and adults alike. The fair was held every year up until 1961. (Author's collection.)

Before everyone had automobiles and improved roads that drew people out of town for entertainment, Hubbardston had many social functions, such as band concerts, church fairs, and dances every Saturday night at the Finn Hall. Events such as the None-Such Street Fair attracted just about everyone in town. Here is a pie-eating contest at the None-Such Street Fair. From left to right are Larry, Gary, and Nancy Kangas. (Author's collection.)

During Hubbardston's bicentennial celebration in 1967, the Louis Richard family turned out in impressive costumes that attracted much notice. The mother, Anne Richard, made the clothes. From left to right are (first row) Kathy, Robert, Jeanne, and Rosemary Richard; (second row) Michael Richard; (third row) Anne and Louis Richard. (Courtesy of the Richard family.)

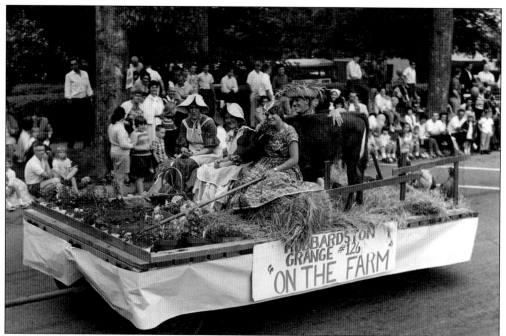

The Hubbardston Grange No. 126 of the Patrons of Husbandry was first organized on November 26, 1885. The Grange was at one time the largest and most influential social organization in town. The Grange fell into a state of decline, and it was discontinued for a period of time during the 1930s. It was rekindled in the 1940s and again fostered a good membership. Above is the Grange float that was in the Hubbardston bicentennial parade in June 1967. The theme was "On the Farm." (Courtesy of Nancy Kangas.)

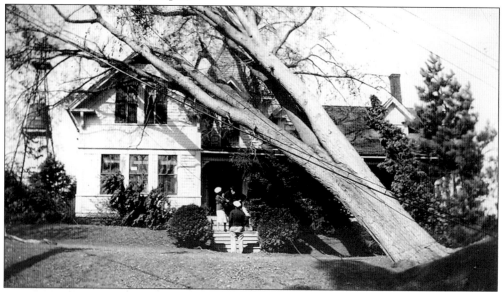

During the hurricane of 1938, tremendous damage was done to Hubbardston's millponds and woodlands. A large number of homes were badly damaged. Several stately elm trees on Main Street were destroyed. Above is Shady Hill Cottage at 7 Brigham Street after a large tree fell on it. (Courtesy of HHS.)

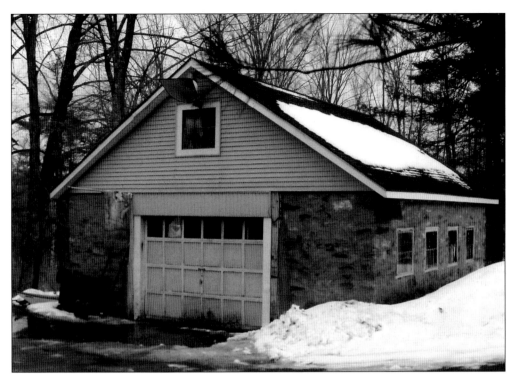

Matti Kalliokoski had a garage on Route 68, where he sold cars and did repairs. When Route 68 was redone, he moved across the street to where the Second Shift garage is now. There he sold gasoline and did inspections. (Author's collection.)

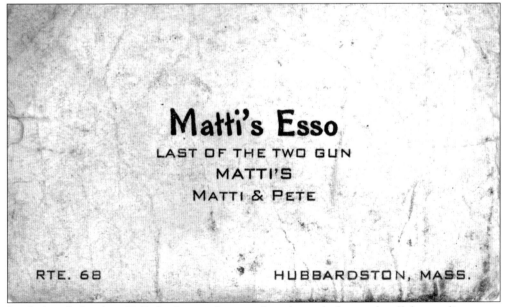

Just before dark, when Kalliokoski was about to close, he took the nozzle off the gasoline pump and poured some in his mouth. He then struck a wooden match and blew the gasoline out as it ignited like a dragon, attracting many evening customers. He always wore two revolvers on his hips and was known as "Two Gun Matti." (Author's collection.)

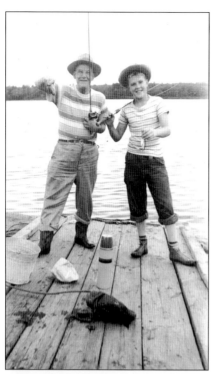

Comet Pond, Hubbardston's largest body of water, has had four different names: Asnaconcomick, Asnecomcomit, Asnacomet, and Comet Pond. The spring-fed pond stayed fresh and clear and was a great place for swimming and boating despite the fact that there was not much of a beach for many years. Here are David Valley and James Hume showing off their big catch. (Courtesy of Velma Rivers.)

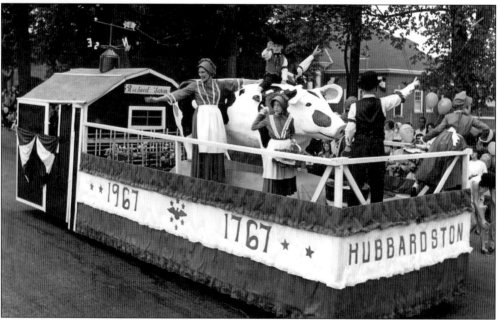

The Richard farm family float in the bicentennial parade in 1967 consisted of a 600-pound black-and-white pig made of plaster and cement and a red barn, complete with weather vane and hay fork. Louis Richard designed the entire float. On the float are Louis, his wife, Anne, and their children Michael, Kathy, Rosemary, Jeanne, and Robert. It was made in red, white, and blue, which are the colors of the Royal Cadets Drum and Bugle Corp band of Gardner. (Courtesy of the Richard family.)

# CENTENNIAL CELEBRATION,

HUBBARDSTON,

**Thursday, June 13th, 1867.**

## PROGRAMME:

### In the Pavilion.

1. MUSIC BY THE BAND..............................................
2. READING OF SCRIPTURES..........................................
3. QUARTETTE. "Home Again"........................................
4. PRAYER.........................................................
5. ANTHEM.

   TUNE—"*Auld Lang Syne.*"

   Should auld acquaintance be forgot,
   And never brought to mind—
   Should auld acquaintance be forgot,
   And songs of auld lang Syne.
   For auld lang syne we meet to-day,
   For auld lang syne,
   To sing the songs our fathers sang
   In days of auld lang syne.

   We've passed through many varied scenes,
   Since youth's unclouded day;
   And friends, and hopes, and happy dreams,
   Time's hand hath swept away.
   And voices that once joined with ours,
   In days of auld lang syne,
   Are silent now, and blend no more
   In songs of auld lang syne.

   Yet ever has the light of song
   Illum'd our darkest hours,
   And cheered us on life's toilsome way,
   And gemm'd our path with flowers.

   The sacred songs our fathers sang,
   Dear songs of auld lang syne,
   The hallowed songs our fathers sang,
   In days of auld lang syne.

   Here we have met, here we *may* part,
   To meet on earth no more;
   And we may never sing again
   The cherished songs of yore;
   The sacred songs our fathers sang,
   In days of auld lang syne,
   We may not meet to sing again
   The songs of auld lang syne.

   But when we've crossed the sea of life,
   And reached the heavenly shore,
   We'll sing the songs our fathers sang,
   The cherished songs of yore,
   We'll meet to sing diviner strains
   Than those of auld lang syne,
   Immortal songs of praise unknown
   In days of auld lang syne.

6. ADDRESS........................................................
7. ORIGINAL HYMN.

   Since Hubbardston first took its name,
   A hundred years have passed away,
   And here from distant homes we come,
   To celebrate her first birthday.

   We're here because this sacred spot,
   The *old homestead* that gave us birth,
   If left can never be forgot,
   'Mid all the changing scenes of earth

   While friendly greetings we extend,
   And tears of joy unbidden fall,
   Let songs of *Praise* to Him ascend,
   Whose mercy has sustained us all.

   As we look back with mem'ry's eye,
   And mark the progress of our race,
   We feel that blessings from on high,
   Have long been showered upon the place.

   And may a *holy*, hallowed thought,
   Inspire and cheer each throbbing breast,
   As we in sadness view the spot
   Where those old Pilgrim fathers rest.

   Then let us praise our fathers' God,
   Who led them here when all was new,
   Who smoothed the rugged path they trod,
   And watched them all life's journey through.

8. MUSIC BY THE BAND..............................................
9. BENEDICTION....................................................

### At the Table.

1. MUSIC BY THE BAND..............................................
2. BLESSING.......................................................
3. DINNER.........................................................
4. MUSIC BY THE BAND..............................................
5. POEM...........................................................
6. TOASTS, SENTIMENTS, SPEECHES, &c...............................
7. After appropriate Music by the Band, a Benediction will close the exercises of the day.

F. A. Searle, Steam Job Printer, 118 Washington Street, Boston.

It was voted at a town meeting to set aside June 13, 1867, to celebrate the town's centennial. It turned out to be a great celebration, with a grand pavilion on the common, speeches, poem readings, songs, and a parade down a well-decorated Main Street. Refreshments were served at Mechanics Hall, and dinner was served under a tent on the common. More people were assembled on this day than any day in Hubbardston's history up to this time. (Courtesy of HHS.)

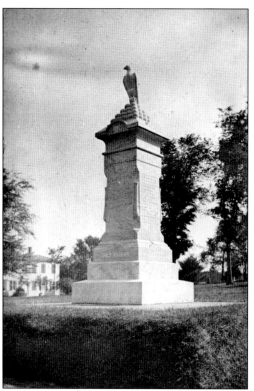

Despite its size, Hubbardston was not able to remain immune to the horrors of war that the American people were confronted with in 1898, 1917, 1941, 1950, and again during the Vietnam era. As had their fathers before them, Hubbardston's men and women answered the call during America's darkest hours, and for some, it was the final calling. Here on the common is the Civil War memorial. (Courtesy of HHS.)

About a mile north of the center of town on New Templeton Road is "big rock." There is a benchmark on a rock on the right side of the road, where one can walk into the woods about 100 feet to find it. Because of its great size, it has been a Hubbardston attraction visited by thousands of people. It is about 100 feet around, and its top is large enough for several people to stand on. (Courtesy of HHS.)

About a mile north of big rock are the Indian Caves. After one passes where the swamps are on both sides of the road, a ledge can be seen high on the left side. There is a steep climb to where the ledge begins, and there are several caves along this ledge. Three windows are carved in it, and below them is a clean-out hole. If a fire is started in this bottom hole, smoke comes out the three holes above. (Author's collection.)

The opening here has a chamber on the right side that goes into a room where two people can sit. The fire set in the bottom hole sends smoke into this chamber, which shows that there are more tunnels and chambers to be found inside this ledge. About a half mile north of these caves is a mine that contained copperas, a useful mineral that was mined in the 19th century. (Author's collection.)

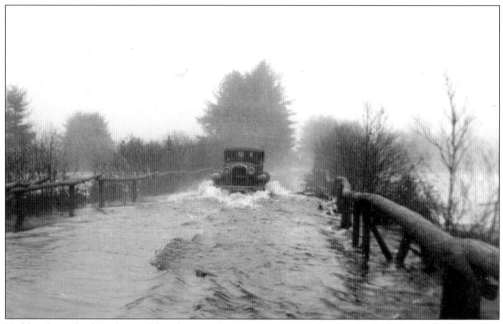

Hubbardston had its share of floods over the years. Between the floods of 1936 and the hurricane and flood of 1938, many of Hubbardston's millpond dams were washed out. Above is Frank Marean in his Model A Ford on the south side of the bridge on Evergreen Road during the flood of 1936. (Courtesy of Velma Rivers.)

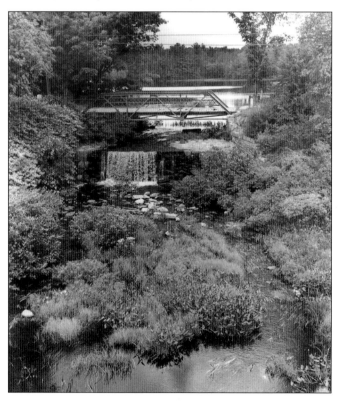

In 1906, the legislature passed the Ware River Act by which the Ware River was impounded through eminent domain. The MDC took over about 20,000 acres of watershed land in the towns of Barre, Hubbardston, Oakham, and Rutland. About 47 percent of Hubbardston is owned by the MDC. This is the Worcester Road bridge on the south side of Brigham Pond, which is now owned by the DCR. (Courtesy of HHS.)

In the mid-1800s, it seemed that most families lived on farms, and each farm had, among other essentials, an orchard. Usually it was an apple orchard, although some of the more venturesome farmers had extensive plantings of pears and blueberries. (Courtesy of Velma Rivers.)

Hubbardston has always had great potential for the growth of strawberries, blueberries, and raspberries on a large scale, despite the high elevation, which negated the prospects of any prolonged growing season. There were several blueberry farms and camps in Hubbardston where people came from the city to live during the blueberry season. (Courtesy of HHS.)

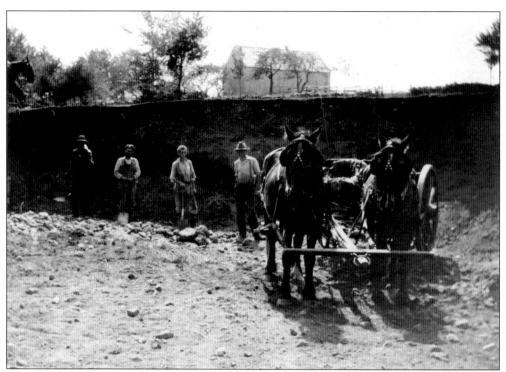

Hubbardston is known for its gravel pits, especially in the Pitcherville area of town. These photographs are believed to be of some construction on Barre Road or maybe just the mining of the gravel for construction or landfills. (Courtesy of HHS.)

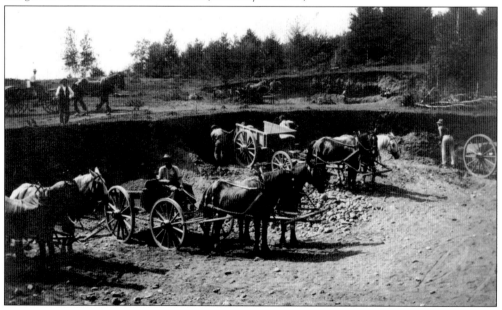

Here is a steam shovel being used on the Barre Road when the road was under construction. This was great technology of the day, as previously gravel was moved by hand. The first hydraulic backhoe was invented only about a half mile down the road. (Courtesy of Velma Rivers.)

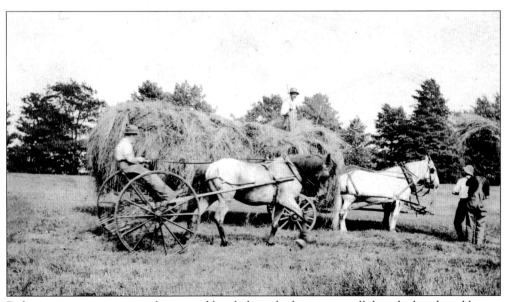

Before tractors, mowing machines, and hay balers, the haying was all done by hand, and horses were used to pull wagons. A sickle or scythe was used to cut the hay. The loose hay was then pitched up onto the wagon, hence the term *pitchfork*. (Courtesy of Charles Clark.)

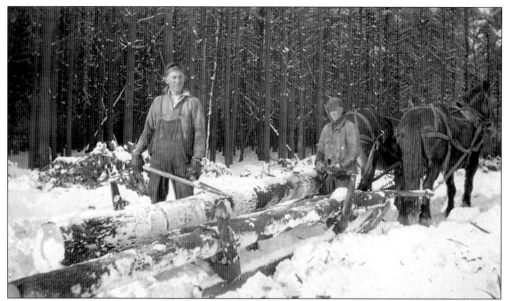

Logging was usually done in winter because much of the sap had moved down to the roots of the trees, and the wood dried faster when it was cut in cold weather. Farmers were busy other times of the year planting crops, haying, and harvesting; during the winter, more time was available for harvesting wood. The snow cover also made it much easier to drag the logs out of the woods, as seen in this photograph. (Courtesy of HHS.)

Hubbardston had several sawmills in town over the years. They were powered primarily by water in the early years; later some were powered by steam and then by diesel. This is the Curtis lumber mill that was in Slab City on Old Princeton Road. This mill was destroyed by fire twice over the years and then rebuilt. (Courtesy of HHS.)

# Seven
# Center School

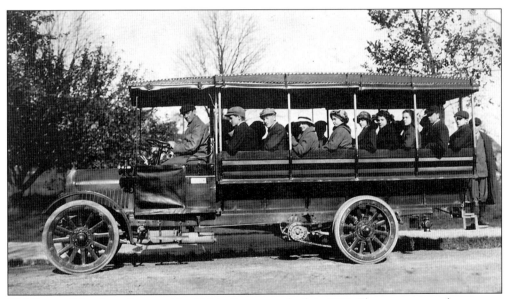

Old Center School, on the east side of Main Street, was built in 1872. There were several one-room schoolhouses in use when transportation from the many villages was not feasible. After the advent of the automobile, when children reached the seventh grade, they were transported on a bus to Center School in town. Pictured is an early bus that was used in Hubbardston. This bus also transported the older students to Gardner, as Hubbardston did not have its own high school until it joined the Quabbin Regional School District in 1967. (Courtesy of HHS.)

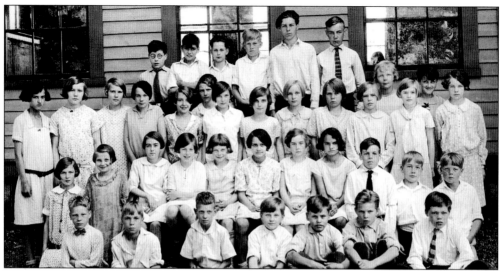

Pictured are sixth-grade students in 1929. From left to right are (first row) Charles Healey, Ero Ahola, Gordon Clark, Edwin Maki, Waino Hakkinen, Dana Prentiss, and Stanley Blaisdell; (second row) Elsie Fowler, Constance Church, Florence Maynard, Ruth Shaffer, Evelyn Wead, Lorraine Bishop, Evelyn Clark, Mildred Hawksworth, Lester White, Martin Rusteoja, and Weikko Mackie; (third row) Edna Hawksworth, Helen Sippila Holm, Siska Kuusisto, Catherine Noone, Elizabeth Louisa, Frye Graham, Phyllis Meagher, Constance Brown Bumpus, Elsie Uskavet, Vieno Ahola Prentiss, Kathryn Prentiss Orcutt, Helen Valley Mahoney, Sylvia Hamilton Winter, Alice Shaffer Johnson, Barbara Bishop, and Ruth Meagher; (fourth row) Bernard Ruggieri, Howard Taylor, William Chapman, Henry Mackie, Roy Toothaker, and Andrew Toothaker. (Courtesy of HHS.)

Pictured are third- and fourth-grade students from old Center School in 1931. From left to right are (first row) Sylvia Salmi, Dorothy Chapman, Gertrude Peterson, Helen Maki, Velma Marean, Caroline Bickford, Lily Maki, Helmi Jalonen, Marion Clark, Mary Mulhall, Esther Ylonen, Viola Niemi, and Joseph Avery; (second row) Leslie Fowler, Rudolph Puntanen, William Meagher, Everett Noone, Norman Clark, Weikko Holopainen, Gordon Bennett, Warren Halcott, Donald Rice, Clifton Degnan, Elmer Mannisto, and William Ware; (third row) Taisto Holms, Elwood Taylor, David Bumpus, Earl Meagher, Herman Stone, John Harris, Robert Shaffer, William Curtis Marean, Edwin Mackie, Leon Grow, Lyman Woodard, and Herbert Brigham. (Courtesy of HHS.)

Here are members of the graduating class of 1942. From left to right are (first row) Andrew "Neil" Erickson (marshal), Edith Brigham, Mary Marean, Helmi Hakkinen, Shirley Woodward, Marilyn Clark, Shirley Newcomb, Gertrude Woodland, and Frances Converse (marshal/majorette); (second row) Allen Wells, Raymond Wead Jr., Richard Lyon Jr., Robert Kenney, Ivar Johnson, William Arsenault, Douglas Penttila, and teacher and principal Donald F. Lytle. (Courtesy of HHS.)

Fourth-grade students are pictured here in 1943. From left to right are (first row) Andrew Howlett, Christine Ohlsom, Louise Coppleman, Helen Watts, Eunice Green, June Newcomb, Helen Wironen, Priscilla Clark, and Harold Slaney; (second row) Charles Wilson, Arthur Erickson, John Adams, Robert Lindsten, William Valley, Ralph Roman, Rayford Rumrill, Lysander Jolly, Walter May, and George Marean. (Courtesy of HHS.)

Students from grades three and four are pictured here in 1949. From left to right are (first row) Joyce Fisher, Mary Halfrey, Betty Tayler, Ruth Barrett, Eleanor Pike, Janet Hannula, Sandra Poules, Patricia Novack, and Judy Charette; (second row) Charlton Martz, George Richard, Osmo Tuiskula, Paul Degnan, William Mattson, Edward Zibkowski, Charles Woodward, Dean Blyther, Lester White, Douglas Howlett, and Kenneth Norquist; (third row) James White, Philip Erickson, Richard Thompson, Robert Mannisto, Marilyn Pierce, Nancy Kujala, Ronald Juvonen, David Coffin, and Walter Murdock. The teacher was Anne M. Novack. (Courtesy of HHS.)

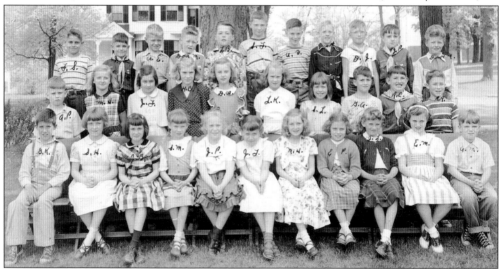

These third- and fourth-grade students are pictured in 1951. From left to right are (first row) George Kangas, Sandra Holden, Judy Bishop, Sandra Merikanto, Judith Prose, Jerilyn Fisher, Nancy Heald, unidentified, Eleanor Mattila, and Alan Mannisto; (second row) Alan Prentiss, Mary Holopainen, Judy Fox, Helen Blyther, Diane Wojdylak, Linda Karkane, Sally Lufkin, Gerald Arsenault, Robert Coffin, and William Rivers; (third row) Frederick Schindler, Jack Clark, Alan Erickson, Donald Marean, Lewis Bishop, Stanley Frizzel, Albert Valley, Wayne Hannula, Donald Juvonen, James Powers, and David Marean. Anne M. Novack was the teacher. (Courtesy of HHS.)

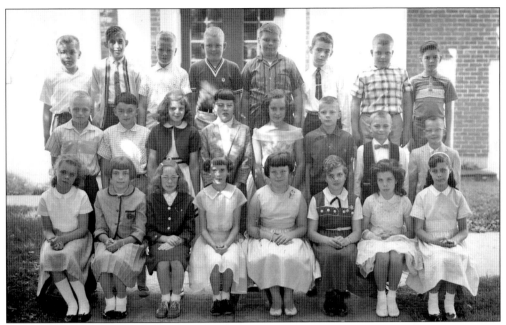

Fifth-grade students pose here in 1960. From left to right are (first row) Dorothy Makela, Sally Holden, Deborah Coffin, Nivienne Provost, Susan Marean, Kathleen Jalonen, Darlene Sawyer, and Holly Chapman; (second row) Richard Nivell, Bruce Valley, Patricia Anderson, Belinda Blood, Stephanie Gramolini, Robert Harty, Robert Ahola, and William Sisco; (third row) John Wilbur, Stanley Davis, Russell Hakala, Arnold Ylonen, William Wilbur, Ronald Hall, Wayne Kujala, and George Sawicki. (Courtesy of HHS.)

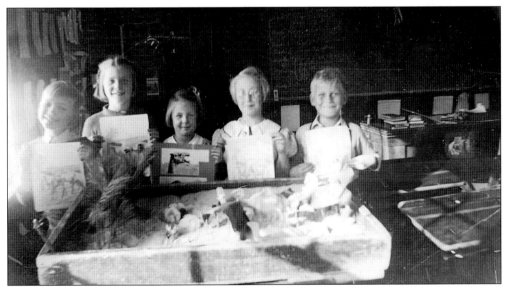

Hubbardston Center School had eight grades up until the autumn of 1967 when Quabbin Regional Junior Senior High School opened. At that time, seventh and eight graders began attending the new school. Around 1973, the state required that all towns provide a public kindergarten for their children. By 1974, Hubbardston had one built in honor of Willard Slade. Here in the early 1950s are some first graders by the sandbox showing off their artwork. (Courtesy of HHS.)

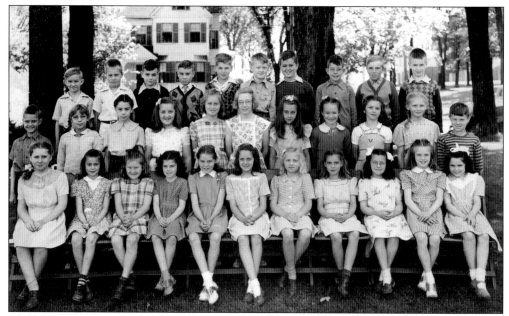

Grades three and four are pictured in 1946. From left to right are (first row) Eleanor Erickson, Joan Charette, Barbara Marean, Roberta Clark, Bette Bumpus, Eileen Smith, Nancy Erickson, Elaine Prentiss, Corrine Maynard, Marjorie Wead, and Virginia Clark; (second row) William White, Elizabeth Mahoney, Jolly Mahoney, Virginia Mahoney, Ann Johnson, Janice Mattila, Juanita Leadbetter, Joan Porko, Carol Mannisto, Jane Adams, Anna Tuiskula, and Robert Hubbard; (third row) Stephen Howlett, William Karkane, Richard Clark, Raymond Medbury, William Bumpus, Ronald Putanen, Robert Nash, Reginald Ayers, Chester Mowrey, and Alden Adams. (Courtesy of HHS.)

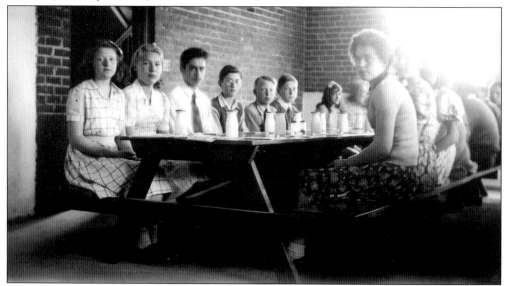

The Hubbardston Center School cafeteria had eight tables for the eight grades that attended at that time. On the right side are Helen Halfrey and Carmen Woodward. From left to right are Barbara Green, Selma Walkinen, Eugne Murdock, Richard Smith, Arthur Waite, John Clark, and Marion Bishop. (Courtesy of HHS.)

Here are grades two and three before the 1954 addition was built. It was not until after the 1954 addition that there was a separate room for each of the eight grades. This was a time when the girls wore dresses or skirts and boys were required to wear dress shirts. Jeans and T-shirts were prohibited. Right up into the late 1960s, if students wore slacks that had even a slight bell-bottom, they were sent home. (Courtesy of Anne Richard.)

This is the playground at Center School around 1950 when the swing was on the south side of the school. In 1954, when the new addition was built, the swing was moved to the north side of the playground. There was also a seesaw and a ball court for the girls. The rest of the field had a baseball diamond that was also used for playing rag football. (Courtesy of HHS.)

Second-grade students are pictured here during the 1950–1951 school year. From left to right are (first row) Gail King, unidentified, Barbara Barrett, Marjorie Chapman, unidentified, Nancy Monolitny, Barbara Babineau, Carol Lufkin, unidentified, and Karen Porko; (second row) David Zibkowski, Billy Sargent, Bernard Ignos, Alden Carpenter, Penrose Leadbetter, Bobby West, and Dennis Olsen; (third row) Charles Fox, Earton Nelson, Alfred Doane, David Bumpus, Henry Ikonen, Danny Haultenen, Charles Lufkin, and George White. (Courtesy of Anne Richard.)

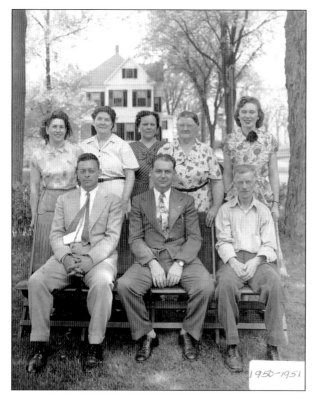

The staff of Center School is pictured during the 1950–1951 school year. From left to right are (first row) Paul Wadleigh, Oliver Millet, and Jake Schaffer; (second row) Hazel Homans, Alice Nolan, Anne Novak, Miss Taylor, and Anne (Henaghin) Richard. (Courtesy of Anne Richard.)

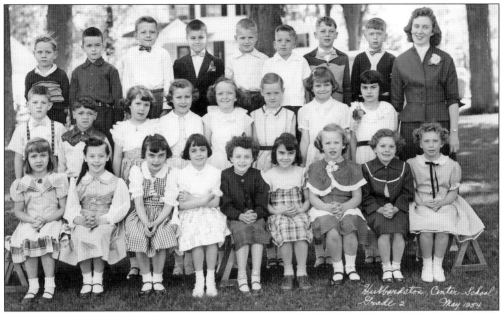

Students in grade two are pictured in 1954. From left to right are (first row) June Babineau, Mary Gaidanowicz, Charlotte Richard, Roberta Clark, Anne Marean, Judith Babineau, Janice Huhtula, Nergenia Humphrey, and Susan Wright; (second row) Joseph Arsenault, Richard Bishop, Susan Bumpus, Susan Wojdylak, Barbara Butler, Janet Erickson, Melinda Hawkins, and Marjorie Murdock; (third row) Larry Schindler, John Hodgen, Carl Anderson, unidentified, Jeffery Dill, Bruce Coffin, Oliver Davis, and Melvin Shepard. (Courtesy of Anne Richard.)

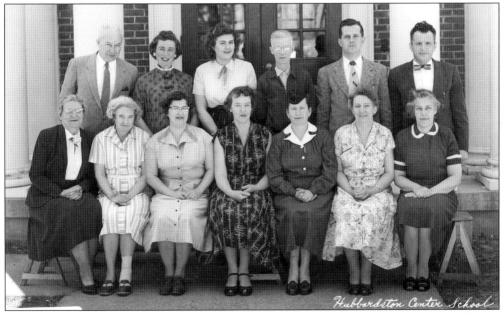

The Center School staff is pictured here during the 1955–1956 school year. From left to right are (first row) unidentified, Agnes Mayo, Claire Fisher, Evelyn Hannula, Kay Brown (nurse), Edna Howlett, and Rachel Prime; (second row) Mr. Snell (superintendent), Anne (Henaghan) Richard, Clara Shaib, Jake Schafer, Dick Fitzgerald, and Joe Gramolini. (Courtesy of Anne Richard.)

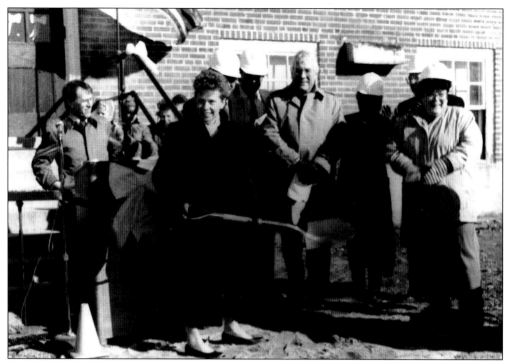

It had taken more time and energy to reach the moment than perhaps ever will be acknowledged or remembered in the years to come, but formal groundbreaking ceremonies for the addition/renovation project at the Hubbardston Center School finally took place on February 1, 1991. Shown above as she prepares to turn the first shovelful of earth, Quabbin Regional School District superintendent Maureen M. Marshall is joined by state senator Robert D. Wetmore (center). Work on the school was completed by the spring of 1992. (Courtesy of HHS.)

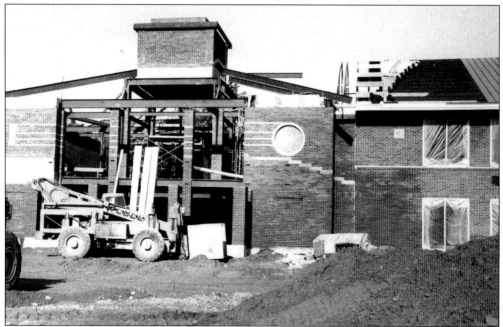

# Eight
# WAIN-ROY COMPANY

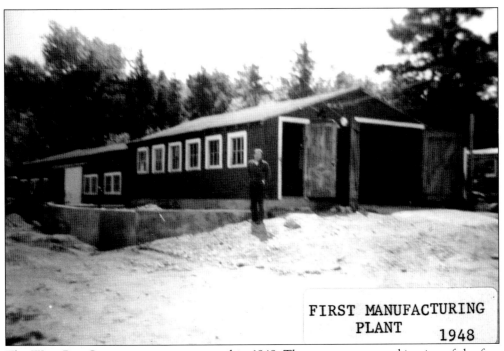

The Wain-Roy Company was incorporated in 1948. The name was a combination of the first names of the partners, Waino Holopainen and Roy Handy Jr. Above is the first manufacturing plant in 1948. Prior to its use for manufacturing, it was a chicken coop. Most of the work in developing the hydraulic backhoe and early manufacturing was done here. (Courtesy of the Handy family.)

This was the first expansion of the Wain-Roy Company. It was a wooden frame structure where the backhoes were made. (Courtesy of the Handy family.)

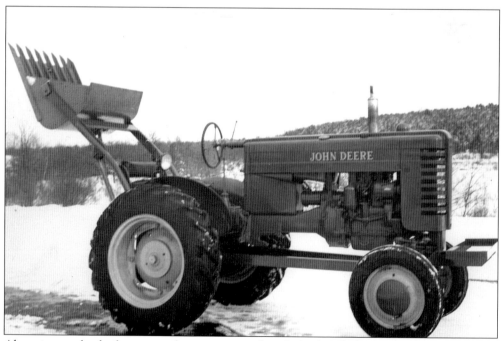

Above is a rear loader for manure that was mounted on the back end of a tractor at the Holopainen farm on Barre Road. This was the beginning, the inspiration for what developed into the world's first hydraulic backhoe. (Courtesy of the Handy family.)

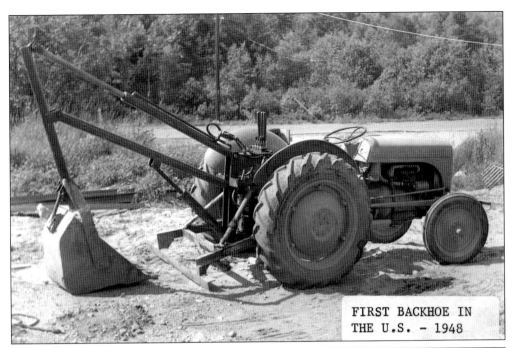

FIRST BACKHOE IN THE U.S. - 1948

This is the world's first hydraulic backhoe, introduced to the market in 1948. When Ford Motor Company got involved, Henry Ford II introduced Waino Holopainen as "Mr. Backhoe." (Courtesy of the Handy family.)

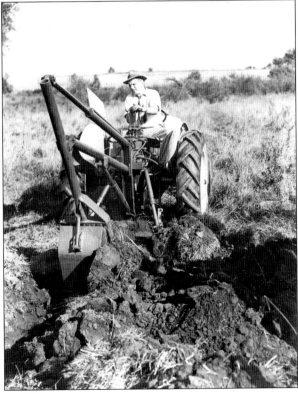

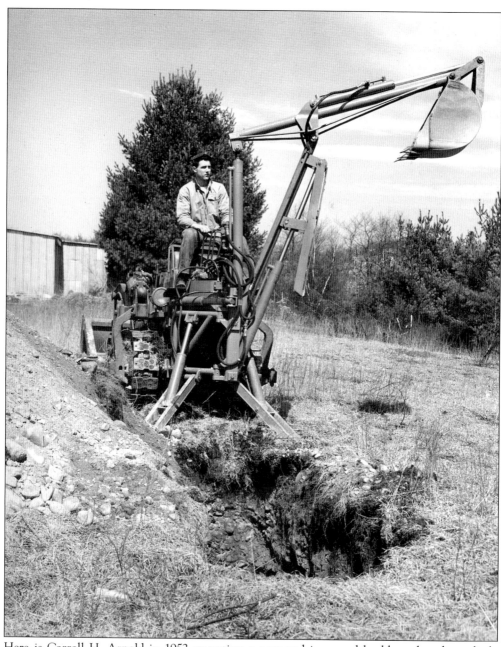

Here is Carroll H. Arnold in 1952 operating a new and improved backhoe that dug a little deeper and had a little more swing. Backhoes were made for a number of years, and in 1962, a tractor, bucket loader, and backhoe was introduced as one integrated unit. (Courtesy of the Handy family.)

By the late 1950s, Wain-Roy Company was in full operation. With the increasing demand for backhoes, more buildings were added to fulfill the need. Wain-Roy was Hubbardston's largest employer and taxpayer. It was located on Route 62 on the way to Princeton. (Courtesy of the Handy family.)

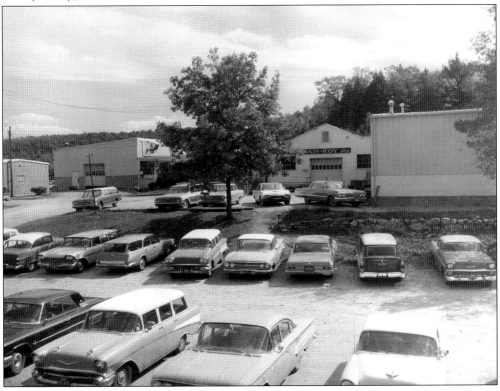

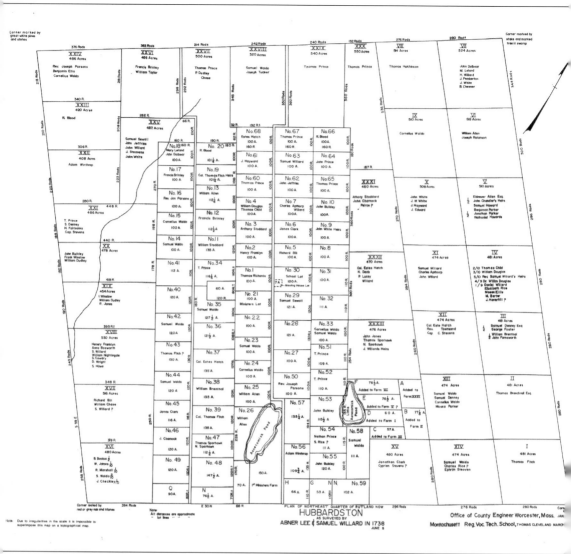

A part of Rutland, this land was purchased from the Naquag Indians in 1686. The northeast quarter of this land later became known as the town of Hubbardston. In 1737, this land was divided into 68 house lots of 100 acres each and 33 great farms of 500 acres each. Various lots were set aside for schools, churches, roads, and a common. This land was offered to pioneers who came and settled here. (Courtesy of Jane McCauley.)

This is a map of the town of Hubbardston as it appeared in 1857. Elm Street was the road to Gardner, and where Route 68 is now was New Templeton Road. It was not until later that Route 68 joined the other end of High Street, and New Templeton road did not begin until farther up. The many sawmills in Hubbardston at this time are marked as well as the 13 one-room schoolhouses that were used. This map shows the many boot- and shoe-making shops that were in Hubbardston in 1857. (Courtesy of Jane McCauley.)

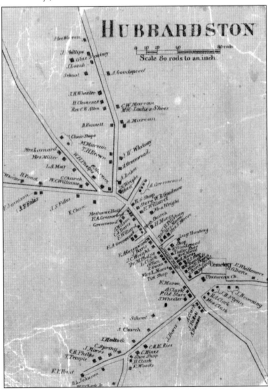

This map of the Main Street area of town shows the layout of the businesses that were there in 1857. Mechanics Hall is shown where the present-day Mr. Mikes is located now, and the store of William B. Goodnow is across the street. There is a tin shop shown where the present-day Jonas Gilman Clark library is located. This map shows that Clark was operating his tin shop at this time. He sold tinware to the California gold miners. (Courtesy of Jane McCauley.)

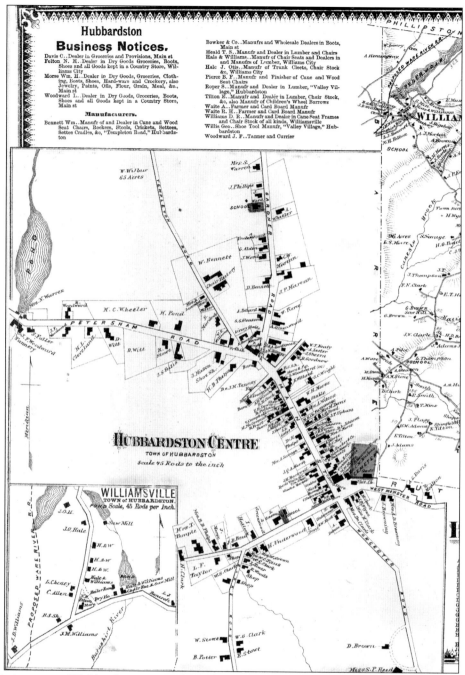

This is a map of Hubbardston center from the Beers Atlas of 1870. The many little shops and stores can be seen. Hubbardston, like all New England towns at this time, was self-sufficient. There was a lot of industry in town providing just about everything the community needed. There was a boot shop halfway down Main Street, and the Wheeler house was then known as the W. H Morse livery stables. William H. Morse also owned the Wheeler store building at this time. The Wheeler brothers did not own the store until 1875. The big hotel that was across the street from where the library is now was called the Crystal House. (Author's collection.)

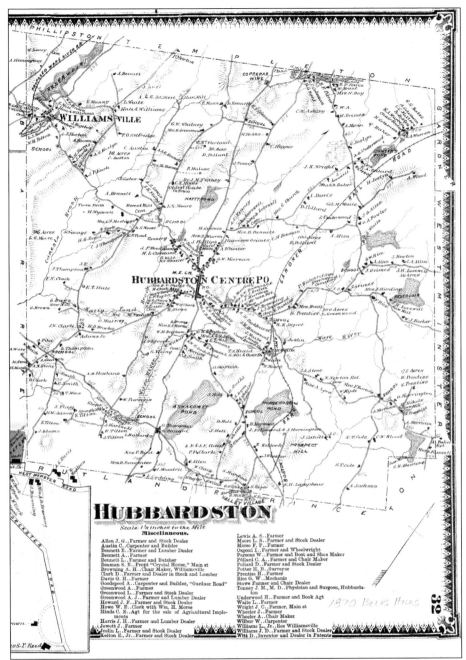

This map of Hubbardston is from the Beers Atlas of 1870. Many of Hubbardston's mill sites and millponds are shown. There is the Howe lumber mill on the north side of Brigham Pond, and in the Pitcherville area of town is where the O. F. Greenwood and B. F. Pierce chair factories were before they relocated to South Gardner. The three millponds in Pitcherville are shown how they were before they were washed out in the flood and hurricane of 1938. On the east side of town are the tracks of the Boston, Barre and Gardner Railroad, which later became Boston and Maine Railroad. Williamsville did not have a railroad line yet, but this map shows the proposed layout of the Ware River Railroad. (Author's collection.)

This is a map of the center of Hubbardston as it was in 1898. By this time, the Wheeler brothers were running the store on the corner of Main Street and Elm Street. The first telephone switchboard office was in operation in their store. The big hotel on the north side of Main Street is now called the Falmouth House, and the Crystal House hotel on the south of Main Street was torn down and replaced with a Victorian house built by Elwin Wheeler. In the midst of the Industrial Revolution, Hubbardston was never the same again after the coming of the railroad, automobiles, and electricity. (Courtesy of HHS.)

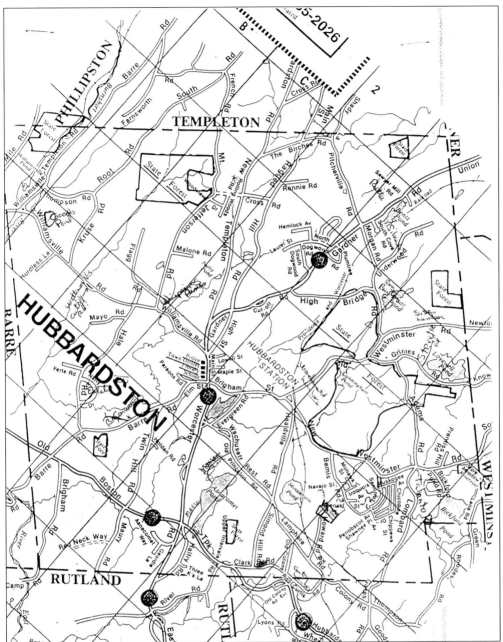

This map shows Hubbardston much as it looks today. Route 68 goes straight through rather than by way of High Street to Gardner. The road was redone in the early 1950s to make it wider and straighter. There are a few cut-off areas still visible, showing how narrow and windy the road was at that time. The coming of the railroad in 1871 had an impact on Hubbardston. Hotels and inns suffered, as there was less need for travelers to stay over and rest. With improved paved roads and automobiles, the railroad as a means for travel dwindled. The Hubbardston station as well as many others closed down in 1955. Hubbardston is no longer the quaint self-sufficient town that it once was. (Courtesy of HHS.)

Here are two icons of the town that were built 100 years apart: the 1874 Jonas Gilman Clark library building and the 1773 First Parish Unitarian Church. This photograph was taken 110 feet up on a crane over the common in October 2008 when the steeple of the Unitarian church was being renovated. No scaffolding was needed, as all the painting and repairs were done from the crane. (Author's collection.)

Here is another view from the crane over the town common in October 2008. The house in the lower part is 3 Brigham Street, where Rev. John M. Stowe lived. The house on the hill is the home of Alden Adams, the possible site where Clark University could have been built if the town had allowed it. (Courtesy of William Brooks.)

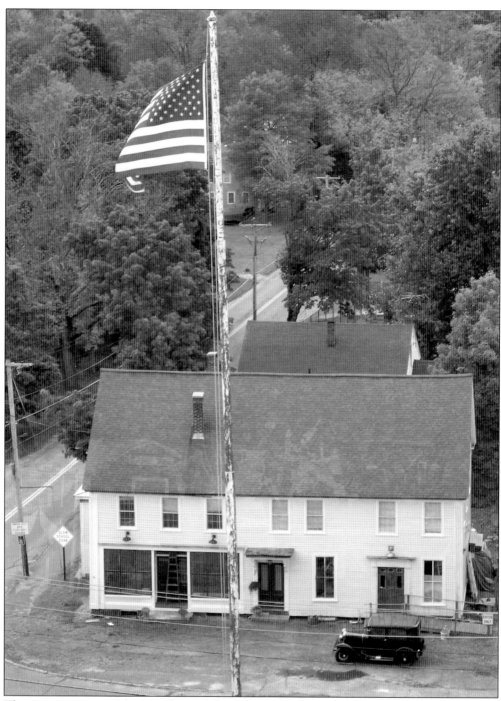

This is a crane view of the Wheelers Brothers General Store as it appears today. The store closed in 1968 when Silas Wheeler retired. The living quarters have been renovated, and the storefront has a for rent sign in the window. The 1930 Ford Model A in front of the store is the author's car, which he has been driving for 30 years. (Author's collection.)

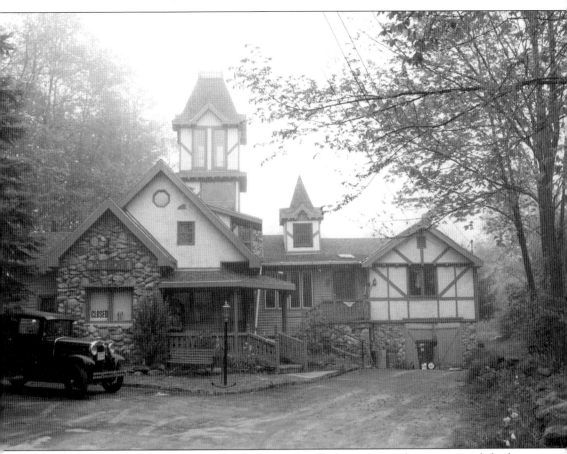

This is the author's house on Parson Road. Originally, the house was a four-room ranch built in 1961. Gary and Donna Kangas purchased the house in November 1976. The house now has seven gables and a 44-foot tower rising from the middle of it. There is a bookcase in the tower, where if the right book is pulled out, a section opens into a secret chamber. The front part of the house is the Anchor bookstore and gift shop. (Author's collection.)

# www.arcadiapublishing.com

Discover books about the town where you grew up, the cities where your friends and families live, the town where your parents met, or even that retirement spot you've been dreaming about. Our Web site provides history lovers with exclusive deals, advanced notification about new titles, e-mail alerts of author events, and much more.

Arcadia Publishing, the leading local history publisher in the United States, is committed to making history accessible and meaningful through publishing books that celebrate and preserve the heritage of America's people and places. Consistent with our mission to preserve history on a local level, this book was printed in South Carolina on American-made paper and manufactured entirely in the United States.

This book carries the accredited Forest Stewardship Council (FSC) label and is printed on 100 percent FSC-certified paper. Products carrying the FSC label are independently certified to assure consumers that they come from forests that are managed to meet the social, economic, and ecological needs of present and future generations.

**Mixed Sources**
Product group from well-managed forests and other controlled sources

Cert no. SW-COC-001530
www.fsc.org
© 1996 Forest Stewardship Council

**Find Your Place in History.**